PAINTING
GREAT MASTERS
BY NUMBERS

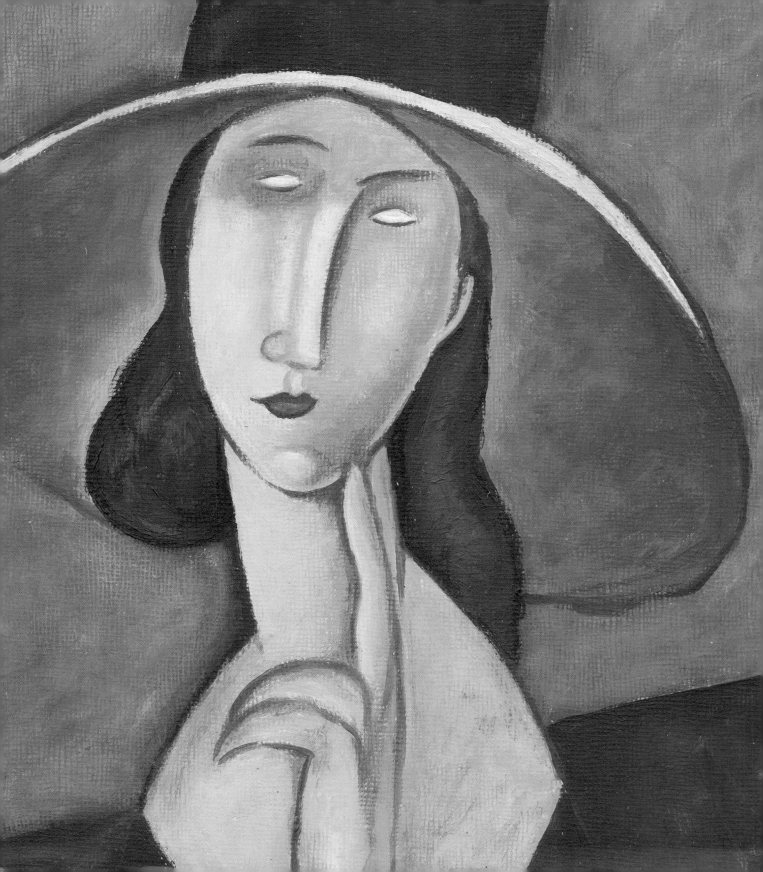

PAINTING GREAT MASTERS
BY NUMBERS

OR HOW TO PAINT WHEN YOU DON'T KNOW HOW

Ivan Hissey with Curtis Tappenden

TED SMART

This edition produced in 2003 for

The Book People Ltd,

Hall Wood Avenue, Haydock,

St. Helens WA11 1UL

Copyright © The Ivy Press Limited 2003

This book was conceived, designed and produced by

THE IVY PRESS LIMITED

The Old Candlemakers

West Street, Lewes

East Sussex BN7 2NZ, UK

THE IVY PRESS

Creative Director Peter Bridgewater

Publisher Sophie Collins

Editorial Director Steve Luck

Design Manager Tony Seddon

Designer Tonwen Jones

Senior Project Editor Caroline Earle

Picture Research Vanessa Fletcher

Originated and printed by

Hong Kong Graphics and Printing Limited, China

1 3 5 7 9 10 8 6 4 2

CONTENTS

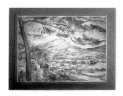
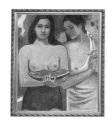
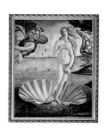

INTRODUCTION

Paintings speak their own rich, lyrical language and seek to attract us with their individual interpretation of the world we live in and the one we imagine. That a collection of expressed marks on a flat surface has the power to describe a person or place and evoke a specific mood or emotion is remarkable. As a communicating art form, painting entices us to enter into dialogue – imparting a conversation of solid structure, good composition, stylistic flair and knowledge. In return we are expected to respond with firm opinion, critical appraisal and, of course, enjoyment in the subject matter being portrayed. What we choose to look at or what we find attractive is highly personal. Beauty is in the eye of the beholder, but most people would readily admit to being touched in a special way by the works of certain painters in history – those we refer to as the Great Masters. From the sensitive, analytical studies of Dürer in the early 16th century right up to Hopper's sobering glances at mid-20th-century urban loneliness, master paintings stand head and shoulders above others because they display so distinctively the inner vision of the artists revealed through their particular skills.

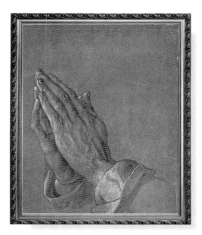

Albrecht Dürer 'Hands of the Apostle'

This book devotes itself to the pursuit of the Great Masters, seeking to open up opportunities to learn about their works and how they were achieved. You will notice three Van Gogh pieces, included as a testament to his amazing passion, inspirational appeal and simply because he is one of the most straightforward artists to copy.

The two Cézanne studies, on the other hand, are included because they show his different facets as still-life colourist and early abstract landscape painter. Every work has been specially selected to guide you through specific techniques and use of media or process. By far, the best way to gain a full appreciation and understanding of painters and painting is to copy them, stroke by stroke. Libraries full of fine books and

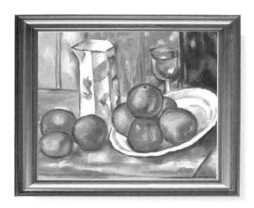

Paul Cézanne
'Kettle, Glass and Plate with Fruit'

classes led by enthusiastic teachers can provide you only with the *information* you need. Learning comes through practice, and practice makes perfect. Make perfection the ultimate goal, but be ready and willing to lower your expectation, especially at the beginning! Painting should remain an enjoyable pastime, and it deserves all the time you can afford to give it. Happy painting!

Edward Hopper 'Nighthawks'

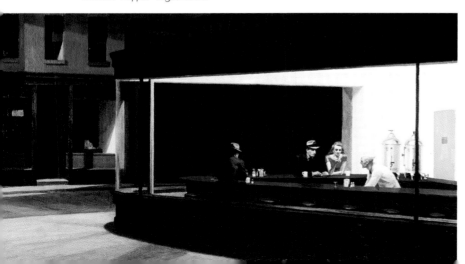

H O W T O U S E T H I S B O O K

Written for those with a passion for art, this book takes a clear and comprehensive look below the surface of the Great Master canvases. The front section introduces the main media used to undertake the projects in the book, namely pastel, watercolour and acrylic. Each has its own treasure trove of techniques just waiting to be unlocked, practised and used in the accomplishment of the projects. You will need a basic drawing and painting kit, and each assignment lists its specific requirements at the beginning. The second section contains thirty classic paintings to copy, which are broken down into step-by-step sequences, fully supported by helpful notes and a short biography. Templates to assist your drawing are supplied in the third section with a colour key.

Using the templates

The templates in the last section of this book have been specially created on squared paper to assist your accuracy in the early stages of drawing. Each template has an outline of the main elements contained within the corresponding master painting. Obviously, where the original was a spontaneous fusion of paint marks, these have been simplified into easy-to-copy shapes – in an Impressionist painting, for example – and the hard-edged lines serve only as a guide. Try not to let the rigidity of the template dictate the movement and direction of the paint as it caresses the picture surface; instead, follow the spirit of the master. You will appreciate that an exact match of colour per square is impossible, especially where there are a number of paint layers and techniques present, and the traditional paint-by-numbers formula would result in peculiar, flat, stylised paintings that would barely resemble the original. It is for you to take courage, to practise and learn from the Great Masters.

Enlarging the template

The templates are scaled down and proportionate. There are a number of methods you can follow to scale them up to fit the recommended canvas and paper sizes:
1. Redraw the grid with each square, say, three times greater than those of the template. Then copy as accurately as you can the information as it is positioned in each square.
2. Enlarge the template in sections on a photocopier in A4 or A3 sizes and join them together.
3. Scan the template into a personal computer and print out the tiled sheets as recommended by the program.
4. Use an episcope projector, which will project enlarged positive images onto a wall or screen.
5. Photocopy the template onto clear acetate, and project it onto a wall using an overhead projector.
For both projection methods, you will need to support your canvas/paper in a rigid, upright position, for example, on a chair or easel.

Transferring the template

Trace the image using either tracing paper or red chalk copy paper, available from good art stores and stationers. If tracing with ordinary tracing paper, use a medium-soft pencil, B or 2B, and shade lightly over the back of the outline template so that the reverse side is covered with the grey tone of graphite. Place this template into position on the canvas, and secure it with a little masking tape in each corner. Press through the front with a fairly sharp pencil point – B or HB is good. There is no need to do this with the red chalk paper. Simply place the paper, red chalk facing down, onto the painting surface, and place the template on top of this. Make sure that both are lightly taped down so that they do not move.

The colour palettes

The paint-by-numbers system set out in this book is not so rigid, in that each mark you make is numbered. This would be stifling, and impossible to deliver for an Impressionist picture! What is set is the choice and number of hues used for the projects. The same palette exists for all the exercises, be it watercolour, pastel or acrylic. The acrylic palette has a range of 28 colours, the pastel palette contains 16 colours and the watercolour palette 19 colours. Paintings will vary. Where, for example, the invigorating work of Toulouse-Lautrec employs 14 of the 28 hues, the more sombre work of Egon Schiele uses only 7 colours. Familiarise yourself with the colours and swatches on pages 12–17.

Painter's Pointer
You will need to check your stock of materials before you put brush to canvas. These are shown on the palette and its information box.

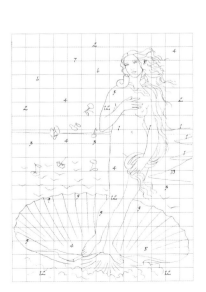

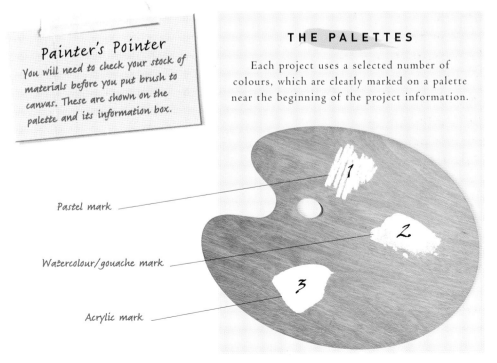

THE PALETTES

Each project uses a selected number of colours, which are clearly marked on a palette near the beginning of the project information.

Pastel mark — 1

Watercolour/gouache mark — 2

Acrylic mark — 3

BASIC TOOLS

To paint like the Great Masters does not require an abundance of expensive 'state-of-the-art' tools that needs constantly updating. The basic supplies, brushes and mark-makers required for the projects are uncomplicated and have changed little over the centuries.

Basic Supplies

You will need the following supplies for all the projects:
1. Apron – to keep you clean.
2. Rubber – to correct any outlining mistakes.
3. Cloth – for blending (and spillages).
4. Waterpot – keep a small bottle filled, too.
5. Palette – a tray on which to mix colours.
6. Pencils – a medium-soft pencil (B or 2B) for shading; a sharp pencil (B or HB) to press over tracing paper.
7. Pencil sharpener – blunt marks compromise accuracy.
8. Canvas board or stretcher – any canvas can be stuck to hardboard or cardboard with white glue (or 'size', bought from art stores), or stretched over a wood frame known as a stretcher. Specially prepared canvas boards can also be purchased. If you are using stretched paper (with watercolours, for example), dampen the paper then lay it evenly onto a wooden drawing board. Dab away excess moisture from the surface and attach the stretched paper to the board with brown tape.
9. Drawing board – a piece of wood or hardboard on which to rest a paper or cardboard canvas for extra support. Make sure that there is a generous 20-cm/ 8-in-or-more width and depth on the board.
10. Easel – to allow a better oversight of your work. You can stand back to check how the painting is shaping up.

Brushes

Drawing directly with a brush is a guaranteed confidence builder. Most of the Great Masters featured in this book used a brush to reinforce their ideas on canvas at an early stage. There is no possibility of rubbing out – mistakes are simply painted over. Varying the choice of brush and type of pigment will determine the character of mark that is made. Which brushes you choose and their sizes is a matter of personal preference, and this book merely makes recommendations. Buying the whole repertoire of brushes can prove expensive for a beginner, so just a few brushes suitable for both watercolour paints, and also oils and acrylic should be ample to start with. Listed opposite are the brushes that have a key function in both watercolour and acrylic painting.

Brush sizes
Watercolour brushes are graded in size from 00000 to 24. Nos. 2, 4 and 6 are a good starter combination.

Bristle

Coarse and springy, bristle brushes are best suited to oil and acrylic painting. They handle thick paint well and are robust enough to be worked against the textured surface of canvas. Apply thick dabs of colour, and work them around the surface, revealing the brushstrokes as you go.

Flats

thin flat brush

These general-purpose, flat-sided brushes are good for large areas, washes and scumbling. They hold paint well.

Brights

bright brush

These have shorter, stiffer bristles than flat-sided brushes and are mainly used for textural effects, such as heavy impasto (paint applied thickly) or scraping back.

Filberts

filbert brush

A sort of flat brush, but the filbert differs because it is softer and tapers slightly at the bristle end. It can produce a fine line when turned on its edge.

Rounds

large round brush

Very versatile brushes with a multitude of uses, rounds make soft strokes and hold the most paint. Rounds have long bristles that taper to a point. They hold large amounts of diluted pigment and so are ideal for underpainting.

Sable and synthetic

These brushes are very soft and ideal for watercolour, gouache and finer detailing with oil and acrylic. Care and attention must be given to them immediately after use, when they should be washed thoroughly with warm, soapy water and reshaped while damp.

Flats

thick flat brush

Made with a full carrying capacity, flat brushes are used to lay broad washes, or firm chisel-edged linear strokes.

Wash and mop

wash and mop brush

These are wider and flatter, with a large round head. They tend to be used for laying in large areas of paint quickly.

Rounds

medium round brush

Useful for washes, a fine or broad strokes, these springy point-ended tools also come in shorter lengths (spotters) and longer lengths (riggers).

Oriental

oriental brush

Set in a bamboo handle, these soft brushes are made of goat, deer or rabbit hair. Available from art stores or specialised Chinese stores, these brushes are inexpensive and produce delicate lines and soft washes.

P A S T E L

Pastel is so often viewed as a drawing medium, and because of the absence of brushes, it is not considered something that you 'paint' with. However, in building up rich and textured layers of colour with pastel sticks, the result is comparable with any painting in watercolour or acrylic.

History

Immediate, velvety soft, freshly coloured and a little over 200 years old, pastel sticks are powdered pigments that have been bound together by a gum or resin. Peter Paul Rubens (1577–1640) used black, white and red in a richly seductive way, but it was not until Edgar Degas (1834–1917) that pastel's full extent as a painterly medium was widely realised.

Uses

The common myth that pastel is a messy drawing medium with limited blending potential has wrongly caused it to be relegated to the narrow field of still-life and portrait-drawing classes. In fact, unlike watercolour or oil, its wonderful versatility is rarely exploited – it is a highly technical and sophisticated dry 'painting' medium just waiting to be creatively explored. The best painting surfaces (also known as supports) for pastels are watercolour and drawing papers – try experimenting with tinted papers, too. A specialised pastel paper known as Ingres can also be bought in pads from good art stores. Practise the pastel techniques shown opposite to build up your confidence, and then follow the master, Edgar Degas, on pages 34–37.

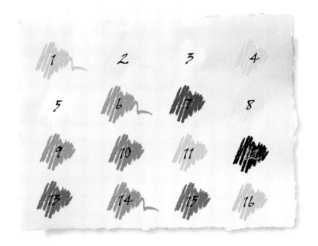

PASTEL COLOUR PALETTE

1	Yellow ochre	9	Light brown
2	Cadmium yellow	10	Ultramarine
3	Cream	11	Light green
4	Light grey	12	Black
5	White	13	Sepia
6	Turquoise	14	Burnt sienna
7	Lilac	15	Bright red
8	Light blue	16	Pink

Techniques

Versatile pastel can be blended smoothly, layered, scrubbed or vigorously applied. Practise on a small pad of pastel paper and keep it for future reference.

Pastel as line

Make lines using the tip. The degree of pressure you apply will determine the width of the mark. Control lines from light to heavy, and if a stick breaks, make a crisp line.

Scumbling

As with paint, semi-opaque layers loosely applied in a circular fashion can modify colour or unify and soften a picture. This is known as scumbling.

Side strokes

Lay the pastel stick on its side and sweep broadly to cover larger areas. Blend the strokes or use in combination with other contrasting techniques, for example, line. The texture of mark will vary enormously depending on paper surface – smooth paper for greater colour density, rough for a grainy, broken effect.

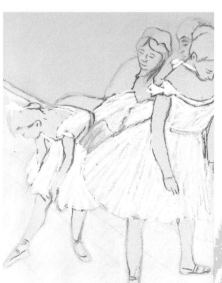

Wet brushing

Mastered by Edgar Degas, this technique involves lifting pastel dust with a dampened brush. Over side strokes it gives a grainy texture.

Mixing

Mix similar or contrasting colours by blending them with a rag, torchon or finger. The overall softness obtained makes an excellent base. Optical blending can be achieved by running fine strokes of two or more colours next to each other. Viewed from a distance, the marks appear to merge into a new colour. Feathering is the application of light directional strokes, and can be used to change tonal values.

The Impressionist Edgar Degas was a true master of the pastel medium.

WATERCOLOUR AND GOUACHE

Soft colour harmonies, luminosity, transparency of layers and flowing pigment are some of the many qualities in the medium of watercolour or gouache, best worked with sable or soft synthetic brushes.

History

The Ancient Egyptians used water as a dilutant in paint, and medieval illustrators added opaque body colour (the forerunner to gouache) as a background for gold leaf. The addition of the binder (gum arabic) to finely ground pigment produced what we now recognise as watercolour. Dürer was among the first to use it for tinting paper and recording the atmospheric nuances of the landscape, a genre fully exploited later by J. M. W. Turner.

Papers

The best painting surface or support for watercolour is paper – especially made as hot-pressed paper (smooth-textured), cold-pressed or NOT (not hot-pressed) paper (medium-textured) and rough paper (coarse). Sample sheets of each kind to get a feel for what they can offer.

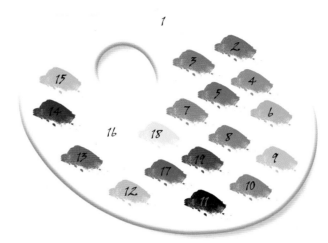

WATERCOLOUR AND GOUACHE PALETTE

1	Chrome yellow	11	Black
2	Vermilion	12	Flesh tint
3	Burnt sienna	13	Payne's grey
4	Ultramarine	14	Violet
5	Prussian blue	15	Sap green
6	Viridian green	16	White
7	Sepia	17	Cobalt blue
8	Carmine	18	Cadmium yellow
9	Yellow ochre	19	Burnt umber
10	Crimson		

Cold-pressed paper

Hot-pressed paper

Rough paper

Techniques

You can use these watercolour techniques with watered-down gouache, or lay it flat and opaque in a creamy consistency, where it will overlap underlying paint.

Wash

For a steady unbroken course of colour, fill a large area with broad sweeps of even paint using a large sable brush, diluting with water as you go to lighten the tone. Flow the colour onto the surface in bands, slightly overlapping.

Wet-on-dry

Add a wet layer to one that has previously dried to help define a shape or to build up dark hues gradually. More than three coats of colour will deaden the translucency. Leave white paper showing through for highlights.

Wet-in-wet

Introduce new colour before the previous one has dried. They will bleed into one another to produce vibrant soft forms.

Scumbling

This technique involves scrubbing a dryish pigment over the painting surface to veil an underlying colour or to unify a picture with a new hue.

Line and wash

An ink line from a fibre-tip or fineliner pen will bleed into a blue-grey tone when water is added, which is the basis for the technique. A nib-drawn India ink line will not bleed, however, when pigment is added.

Dry brush

Build up textures by dragging a dry brush loaded with undiluted pigment across the surface. This may enhance the texture of the paper. It can also be layered using a crosshatched approach.

Stipple

Impressionists and Pointillists dabbed colour to create optically mixing tones and hues in watercolour and oil.

Lifting out

In need of a soft edge or highlight? Gently lift the pigment off with a soft damp rag, sponge or paper towel. This technique is ideal for creating clouds.

ACRYLIC

Thinned as watercolour or thickly spread like oil paint, acrylic is a versatile, modern phenomenon and can be used with most other media. With plastic resin as its binder, acrylic paints dry with enormous flexibility and permanence.

History

The age-old methods of painting, as demonstrated through oil and watercolour practices, seemed likely to dominate forever until the mid-20th century. Suddenly in the early 1950s a new medium burst onto the art scene. As a paint that had been developed in Mexico in the 1920s for mural painters such as Diego Rivera to combat external weather conditions, acrylic suddenly found itself in the high-profile studios of new American Expressionist rebels: Jackson Pollock, Mark Rothko and Robert Motherwell. Today its use and availability is universal.

Supports

The acrylic projects in this book use the medium of acrylic on a canvas surface, but its plastic acrylate resin base is impermeable and will adhere to a very wide range of supports. Paper, board, canvas (primed or unprimed), metal, wood and exterior walls all provide suitable surfaces, but it will not cling to any surface containing wax or oil. Canvas can be stuck to cardboard or stretched over a canvas stretcher (*see page 10*).

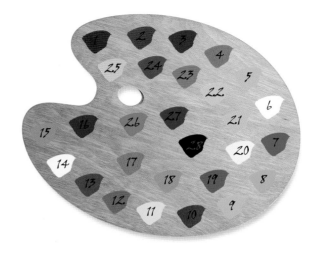

ACRYLIC PALETTE

1	Payne's grey	16	Ultramarine
2	Burnt umber	17	Cadmium orange
3	Violet	18	Raw sienna
4	Crimson	19	Phthalo green
5	Yellow ochre	20	Cream/putty
6	White	21	Pink
7	Cobalt blue	22	Light green
8	Bright green	23	Emerald green
9	Sap green	24	Raw umber
10	Cadmium red	25	Flesh tint
11	Cadmium yellow	26	Cerulean blue
12	Burnt sienna	27	Prussian blue
13	Lilac	28	Black
14	Lemon yellow		
15	Raw sienna		

Techniques

The Great Master projects translate the acrylic medium into traditional ways of working, but the best way forward is to find your own level, depending on whether you prefer to use paint thinly in layers or in thicker slabs.

Glazing

Water or acrylic glaze medium can be mixed with a little acrylic colour to build up thin, fast-drying layers of colour. Applied to heavier-textured paint marks, it can add delicacy and tone down strong sections of a painting.

Washes

As with watercolour, you can lay down dilute, translucent hues, but because of the permanence and quick drying time, there is no suggested limit to the number of washes, and the paint does not become dull and turbid.

Flat colour

Flat colour can be applied opaque with the consistency of heavy cream. Best employed in modern graphic works, you should use the widest brush in your kit to avoid bumpy strokes drying in the paint surface.

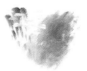

Scumbling

As with watercolour, this technique involves working thick, drying pigment onto a brush and dragging it over the surface in all directions in a random way to loosely tint or unify areas of a painting.

Impasto

This is the term given to the creamy paint that is applied straight from the squeezed tube or pot. Van Gogh was arguably the first exponent of total impasto, inventing a language of uniformly thick swirls and flecks to express his vision. Turner, on the other hand, had successfully combined stiff, protruding paint marks with thin glazes in his evocative picture-making.

Additional and mixed media

You can enrich and enliven the handling quality and appearance of acrylic with various media. Gloss medium enhances colour luminosity, gel medium thickens acrylic for textured work, and modelling paste produces sculptural effects. Combine acrylic with watercolour, gouache, ink or with drawing equipment such as pastel and charcoal to extend the range of possibilities. Overlap underlying paint.

MARK-MAKING

To draw and paint is to make marks. The delicate flowing lines of Dürer's praying hands are nothing more than simple marks drawn in pencil and body colour on a soft watercolour background. The master, of course, had the ability and experience to work wonders with them, turning their organisation into the convincing realm of three dimensionality. Monet's lily pond is as sheets of textured coloured glass, overlapping with broken hues of the previous pane showing clearly through. Up close these exquisite windows are intriguing but say very little beyond the quality of mark they hold. When viewed from afar, however, they burst into reflective brilliance, exposing the realities of light playing on the water surface. Monet has captured, with scrubbed painterly marks, something that we all know and recognise from experience.

This mark-making section introduces you to basic mark-makers and will equip you with the fundamental techniques – as used through the major art movements and up to the present day – designed both to assist your copying of master paintings in this book and enhance your own mark-making skills for creating original works. They are by no means conclusive, and no quick substitute for the ongoing practice of mark-making with dry and wet media.

Broad, tonal
pencil marks.

Graphite pencil
and rubber strokes.

Pencil with watercolour.

Techniques

The techniques listed should be practised to assist the exercises and to draw out your natural leanings.

 ## Pencil

In its various grades of softness, the pencil is extremely versatile and useful for roughing out, drawing outlines and shading rapidly. A good all-round drawing pencil is a B grade, and you should practise scribbling, making tonal scales from dark to light (by altering the pressure), drawing in pure line and building up tone through crosshatching.

 ## Charcoal

Charcoal is great for drawings that need to be adjusted – simply smudge it out and start again. Many Great Masters sketched their composition first in charcoal. Willow charcoal can produce fine, delicate lines or, on its side, much broader blacker marks. Rubbing back with a soft rubber or smudging with a rag or finger makes tones of grey.

 ## Pens

Fine liners and fibre tips give a fluid controllable line, but a nib is more variable in its quality of line because it is pressure sensitive. Sharpened sticks and feathers can produce exciting marks that work well in conjunction with more conventional techniques.

 ## Crosshatch

A traditional line-drawing technique, crosshatching is used to build up a range of optical tones by drawing lines laid at 45-degree angles to one another or varying horizontal, vertical and diagonal lines. The closer the lines are to each other, the darker the tone. This technique can also be used with acrylic, pastel and watercolour.

 ## Line and wash

Pen lines, both mechanical and nib, can be dissolved with a wetted brush to make softer tones from the line. Experiment with both permanent and non-permanent inks and try adding watercolour to the bluish ink stain to enrich the colour. This technique is best achieved on a smooth-textured surface.

 ## Dashes, dots and spatter

Smaller marks made with a nib or with colour flicked from the nib or brush can give a drawing texture for tonal work, providing a good alternative to crosshatch. But make sure that you are wearing an apron when experimenting with the spattering technique!

THE PROJECTS

THE BIRTH OF VENUS

Botticelli

SANDRO BOTTICELLI *1445–1510*

Before you begin . . .

The sheer scale and complexity of this work is too much to handle, so a detail is recommended for study. The scaling down of this copy means that the detail will be more intricate, and therefore a set of finer round sable brushes is recommended, alongside a larger-sized round sable. The smoothness of the painting and its lack of visible brushstrokes lends itself perfectly to the technique's gouache glazes. A sheet of NOT surface watercolour paper is a good support to use, and this should be dampened and stretched onto a wooden board with brown tape. The more costly alternative is a prestretched block of watercolour sheets gummed into a pad – the painting is simply cut away when dry.

Materials needed

1 Basic supplies (page 10)
2 300-gsm NOT watercolour paper (51 cm x 38 cm/ 20 in x 15 in)
3 Gouache tubes
4 Brushes: sable rounds (Nos. 2, 4, 6, 8)
5 2B pencil
6 Red chalk paper

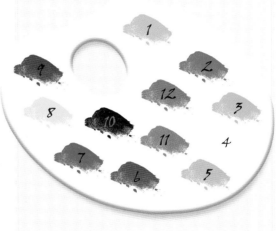

THE PALETTE

The palette is delicate and pearly. Fleshy, understated pinks, ochres and gold support the superb draughtsmanship.

1	Yellow ochre	7	Cobalt blue
2	Prussian blue	8	Cadmium yellow
3	Sap green	9	Burnt umber
4	White	10	Black
5	Flesh tint	11	Crimson
6	Payne's grey	12	Burnt sienna

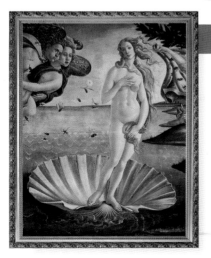

About this painting

☞ Botticelli worked in Florence at the height of the Renaissance, a time when classical poetry and mythology were being searched for superior wisdom and mysterious truths. The powerful Medici family commissioned **The Birth of Venus** as a prodigious secular statement to promote the origin of love and beauty rising as a goddess from the seas. Completed in 1485, the artist achieved perfect harmony through graceful marble-skinned figures depicted with flowing lines and considerable drawing licence. As the wind gods blow her to shore, Venus tilts her head on a very long neck, allowing some strands of hair to blow towards the receiving nymph, the rest conveniently covers her nudity. Botticelli's mastery was forgotten within his lifetime and only rediscovered in the 19th century by the Pre-Raphaelites.

2 LAYING A GROUND

Drop a very thin wash of yellow ochre acrylic across the whole area of the paper with the largest sable brush you have.

The warmth of the painting is due to the original wash of yellow ochre.

1 PREPARING THE PAPER

Prepare the template using the grid on page 144. Transfer the outline onto your paper with red chalk, and enliven the line with a 2B pencil so that it remains bold and clear throughout the project.

Draw carefully and accurately. Good draughtsmanship was a hallmark of Renaissance art.

Do not worry if streaking occurs. It will help to describe the movement of the waves.

TINTING THE SKY 3

Water the Prussian blue gouache down to the consistency of a wash in your porcelain palette.

Be careful to flow your washes around the outline figure. Going over the lines will leave stains that cannot be removed.

Painter's Pointer

Consider the mechanics and colour selection. This version still employs classical principles: the figure set off centre, and the horizontal planes essentially divided into thirds (sky, sea and foreground shell).

4 TINTING THE SEA

In the same way, prepare sap green gouache and tint the lower section of the composition, which is the sea.

TONING THE FIGURE AND SHELL ⑤

The smooth pale skin of Venus and the similar, sensitive colouring of the shell begin to be built up at this stage. Drop a pale wash of yellow ochre, flesh tint and white over both elements.

⑥ **DEFINING THE SEA AND SKY**

Gouache is the ideal medium for laying flat sky and sea tones. Make sure that you mix it in your palette to the consistency of light cream. Work the mixture of Prussian blue, white, and a little Payne's grey with cobalt blue across the sky, smoothly brushing from left to right.

The basis for further refinement has now been set.

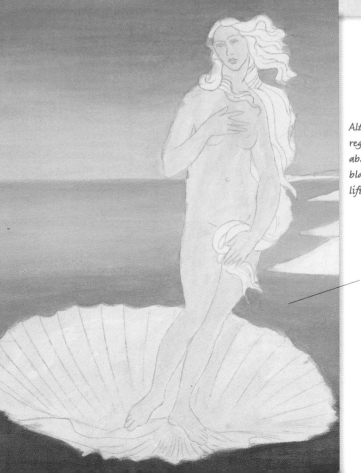

Although generally regarded as the absence of colour, black is handy just to lift the shadow areas.

The sea has a predominance of sap green with added white, plus a minute amount of burnt sienna to harmonise with the pink demeanour.

DETAILING THE SHELL ⑦

Define the ridges in the dish of the shell with a combination of white, cadmium yellow and burnt umber on flesh tint. The two-tone effect of light against dark, emanating from the central point, produces a three-dimensional illusion.

MODELLING THE HAIR AND FLESH 8

The hair requires a thin underlay of cadmium yellow and white before the strands can be illustrated using burnt sienna. Show the fall of light on the body's surfaces with flesh tint and yellow ochre, lightened with white and darkened with burnt sienna. Repeat modelling the tones, using a No. 2 fine sable brush, and blend them wet-in-wet.

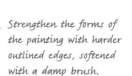

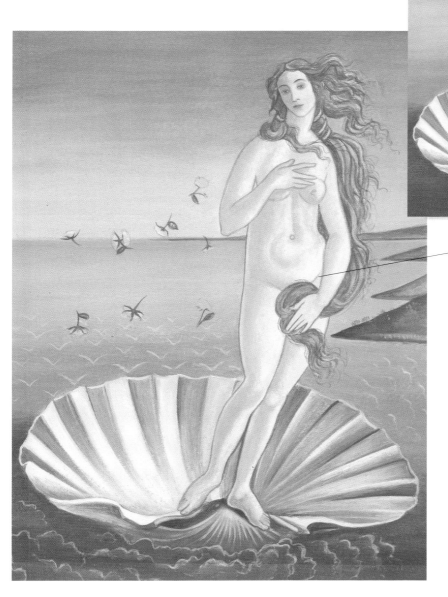

Strengthen the forms of the painting with harder outlined edges, softened with a damp brush.

Keep the wet-in-wet pigment under control, and allow your layers to dry before applying new ones.

9 FINAL DETAILS

Define the floating flowers, wave crests and landscape background using crimson, cadmium yellow, white and burnt sienna on the flowers; yellow ochre, burnt umber and black for the landscape; and white for the waves.

KETTLE, GLASS AND PLATE WITH FRUIT

P. Cézanne

PAUL CÉZANNE 1839–1906

Before you begin . . .

The 'constructive' brushwork is all important in this painting – parallel strokes, often with a diagonal tendency, will help to create the structural solidity. You may find it helpful to use bristle brights for a textured rectangular mark – and filberts – to allow you better control of the brush marks and easier blending. Finer detailing in the angles of the jug and lines of the table and fruit is achievable with a medium-thickness round sable or synthetic brush. In a way similar to that of the Impressionist Renoir, paint a flat, creamy/putty ground to base the picture with the familiar glowing warmth. The placing of cooler tints will enhance any cream showing through the glazes of acrylic.

Materials needed

1 Basic supplies (page 10)
2 Medium-texture (284-g/10-oz) duck cotton canvas (46 cm x 61 cm/ 18 in x 24 in)
3 Acrylic paints
4 Brushes: bristle filberts and bristle brights (Nos. 6, 8, 10)/sable rounds (Nos. 2, 4, 6)
5 Red chalk paper

THE PALETTE

Bold colours, warm and cool, are indispensable. 'We must introduce into our vibrations of light reds, yellows, a sufficient number of bluish hues to convey a feeling of the air,' remarked Cézanne.

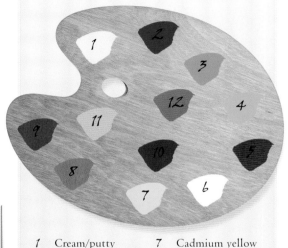

1	Cream/putty	7	Cadmium yellow
2	Ultramarine	8	Cadmium orange
3	Raw sienna	9	Cadmium red
4	Sap green	10	Violet
5	Payne's grey	11	Flesh tint
6	White	12	Burnt sienna

About this painting

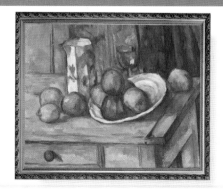

☛ *Paul Cézanne was raised in Aix-en-Provence, near the French Mediterranean coast, and despite frequent sojourns in Paris, his palette and fresh style always reflected the southern climate. A preoccupation with painting from nature was best served by the clear light and tranquil air of the country. A meticulous artist, Cézanne would often work on a single canvas on and off for several years. In this study he exploits a developed method of painting light with strong contrasting colour, making the blues of the background wall panel optically recede, while the warm red-orange of the fruit advances into the foreground. The work has a chromatic richness, structure and solidity, as the artist broods over the still-life arrangement falling towards us under a deliberately tilting perspective.*

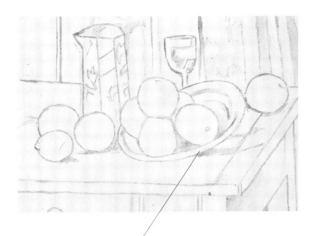

Wash a light tonal blue in the shadow areas at this stage, with wet-in-wet fluidity.

① PREPARING THE CANVAS

Paint a flat, creamy ground to base the picture. Create the template using the grid on page 145, and transfer the sketch using red chalk paper. Lightly outline the tracing with a thin wash of ultramarine with your No. 6 round brush. Establishing strong shapes will stop the elements from being covered with enthusiastic brush marks.

Painter's Pointer

Allow the cream of the canvas to show through the raw sienna underpainting. Deliberately 'missed' areas will assist the warmth of the light and give the composition spontaneity.

LIGHTING THE SCENE ②

The warmth of the whole picture is established by dropping a raw-sienna wash onto the table surface, the legs and panel behind the table.

Already, the emphatic brushstrokes in green and blue give a sense of depth to the scene.

③ APPLYING BACKGROUND COLOUR

With short downward strokes, work the wall with a mottled texture of sap green, ultramarine, Payne's grey and white.

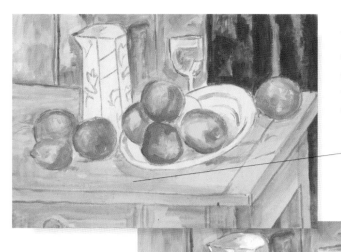

4 APPLYING THE FOREGROUND

The fruit is brought to life with a vivid mix of
cadmium yellow, cadmium orange and cadmium red,
each applied in short, flat marks of 'fat' paint. Start
with the yellow first, as it is the lightest colour, and
merge the other two, wet-in-wet, onto the canvas.

*Give the impression of
a solid table surface
with applied shadows in
ultramarine and violet.*

5 HEIGHTENING REALITY

The cylindrical jug emphasising the
vertical plane of the picture is given
solidity with white on the surfaces
meeting the light, and ultramarine
with violet on those turned away from
it. The shadow on the dish is treated
in an identical way.

*Flesh tint takes the
starkness off the white
and brings it into the
harmonious warmth.*

*Enhance the shadows
on top of the textured
table-top using sap
green and ultramarine.*

DEVELOPING TEXTURE 6

A medium filbert is best employed
for creating the blotchy brown
table-top textures. Raw sienna,
cadmium orange, burnt sienna,
cadmium yellow, a tiny amount of
cadmium red, and white should be
amalgamated and then blended,
following the original.

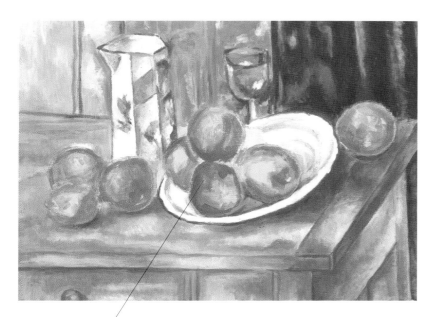

Note how the orangey reds accentuate the roundness of the fruit forms.

7 REFINING DETAILS

The patterns on the jug and reflections on the glass and plate give the painting extra density and substance. The depth of the colour glazes built into the objects on the table are offset by additional wet-in-wet blending of the background curtain and panelling.

FINISHING TOUCHES 8

Push around the outlines one more time with a medium and fine round sable brush, and strengthen the forms with ultramarine and lilac. Model the fruit a little more using cadmium red and lilac, and stop when you feel that you have created the three-dimensional illusion.

Come back to the painting after a day or two with fresh eyes, and decide whether there are any further adjustments to make.

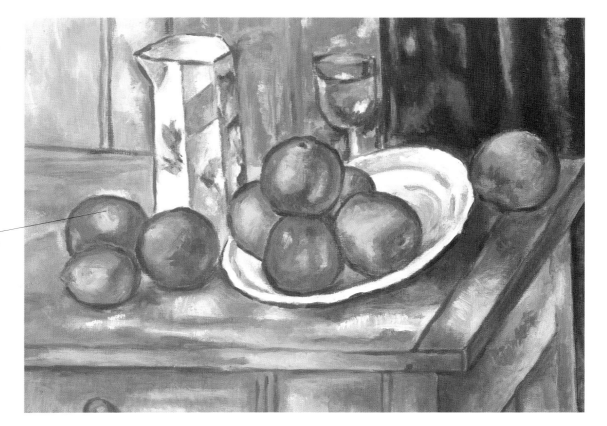

MONT SAINTE-VICTOIRE

P. Cézanne

PAUL CÉZANNE *1839–1906*

Before you begin . . .

The controlled direction of mark is all important here, because it is a recognisable feature of Cézanne's work. The brushstrokes all follow the forms and lead the eye to further depths and vanishing points. His palette is simple and engages the principles of aerial perspective – as the pictorial elements recede, they become paler and bluer, creating the illusion of distance. The brushstrokes are also smoother and less broken. It was important for Cézanne to work on pale grounds to allow the light to show through gaps in the thin paint layers. His discoveries with colour and structure have been termed the single most important influence on Cubism, and he prepared the way for painting in the 20th century.

Materials needed

1 Basic supplies (page 10)
2 Medium-woven-texture white canvas board (41 cm x 71 cm/ 16 in x 28 in)
3 Acrylic paints
4 Brushes: bristle brights and filberts (Nos. 6, 8, 10)/sable rounds (Nos. 2, 4)
5 Red chalk paper
6 Brown conté pencil

THE PALETTE

The interaction of Cézanne's palette of warm and cool colours sets up a heated tension that sparks into life on the canvas.

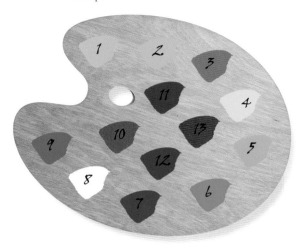

1	Sap green	8	White
2	Yellow ochre	9	Cobalt blue
3	Burnt sienna	10	Cadmium red
4	Cadmium yellow	11	Violet
5	Bright green	12	Ultramarine
6	Cerulean blue	13	Payne's grey
7	Prussian blue		

About this painting

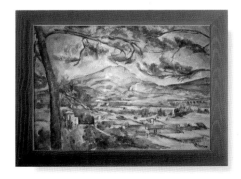

Cézanne had a fascination for exploring beneath the surface attributes of colour and tone to articulate the underlying forms. He saw that the Impressionists had conveyed a sense of reality through colour, but not a sense of solidity and structure that clearly existed in nature. The scene here is bathed in light, but at the same time is solid. The patterned arrangement is strong yet still gives the impression of distance. Cézanne deliberately set the horizontals of the viaduct and diagonals of the road in the centre of the composition. The road has a vanishing point beyond the canvas, and the main verticals are in the lower foreground, with the tree stretching from top to bottom across the picture planes. With his strokes blending in with these structured lines, the harmony is strengthened.

PRIMING THE CANVAS

White emulsion, with a hint of watered-down yellow ochre stirred in, will give you a suitable ground. Broadly cover the entire canvas using a large, flat-bristle brush.

Notice how the conté pencil picks out the texture of the board and dictates the attitude for broken painting.

TRACING THE OUTLINE

Prepare the template using the grid on page 146. Trace the outline with red chalk paper and follow the powdery marks with the firmer line of a brown conté pencil.

The short, dabbed marks give the picture extensive depth. Let the bare canvas work as the lighter tone.

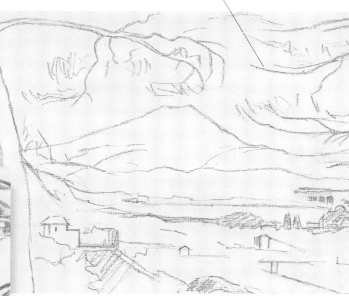

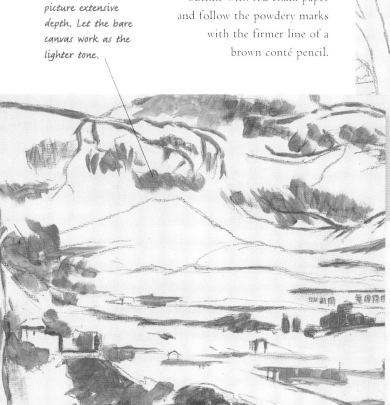

ESTABLISHING FOLIAGE

Brush in the darker tones with a mixture of sap green, yellow ochre and burnt sienna, and gently apply with a light, scumbling technique. Hedgerows and foliage should be expressed in short directional strokes with a medium-sized flat brush, following Cézanne's compositional planes.

CREATING THE FOREGROUND AND MIDDLE DISTANCE ④

Bring fields and foliage to life by working cadmium yellow, bright green and cerulean blue into the picture.

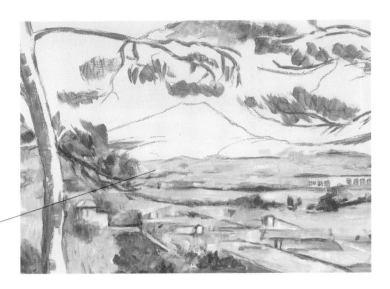

Receding wet-in-wet splashes of Prussian blue and white react against the drier, strong primaries and create a sense of reality.

DEFINING THE MOUNTAIN ⑤

Turn your attention to the distant mountain, and define its undulating bulk predominantly in white with cobalt blue, cadmium yellow, cadmium red and a little violet.

The warm sky complements the cooler land surfaces.

Study the nature of Cézanne's brushwork, and emulate the considered and meticulous worker.

LAYING THE WARM SKY ⑥

The sky is not just blue. Dry, chalky white has ultramarine and yellow ochre scumbled into its pale base. Extra warmth is added directly to selected areas of the canvas with a mix of cadmium red and cobalt blue.

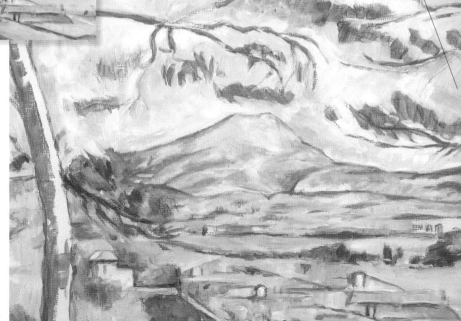

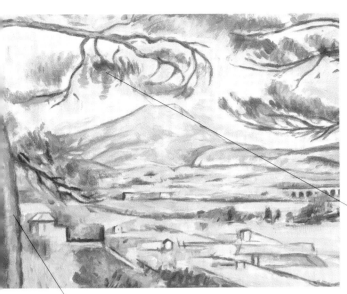

ADDING FINER DETAIL

With a medium round brush, structure the trunk and branches of the foreground tree, using yellow ochre, burnt sienna, cadmium yellow and sap green. Start with yellow ochre near the horizon and gradually add sap green and burnt sienna to the lower parts.

Paint leaves with a flat brush.

MASTER STROKES

Just a few extra marks can make a huge difference. Apply touches of pigment to the trees and further define the hedgerows and viaduct with a flat-edged brush.

Further describe the form of the trunk with strokes of Payne's grey.

Give the whole composition a lift with cadmium yellow in the horizontal folds of the flat fields.

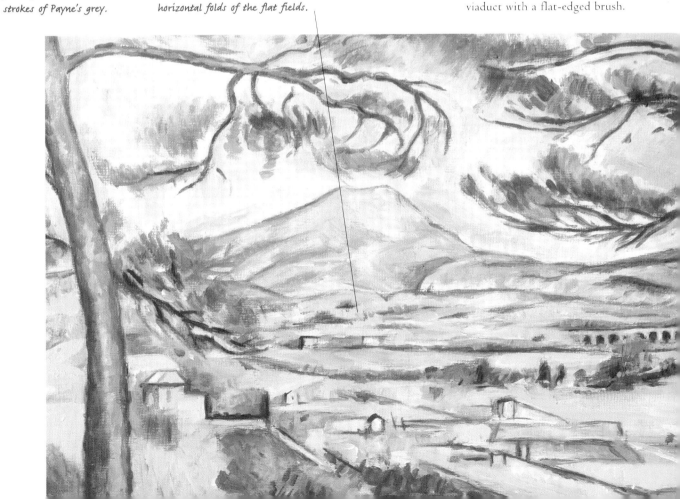

THE DANCE EXAMINATION

EDGAR DEGAS *1834–1917*

Before you begin . . .

In the period during which this work was completed, Degas applied pastel as you might expect in painted layers of colour and line. Crossing striations of crumbling chalk were built into a web through which the hues of previous layers were visible. Implementing this technique is extremely fulfilling, and you can relax knowing that there are no rapid drying times. You will need a box of soft chalk pastels containing the colours as listed in the palette box, or make up your own set from individually bought sticks. Buy the best quality you can afford, because there is no substitute for good materials. You will also need charcoal for the initial drawing and additional items, including torchons for blending and fixative to prevent smudging.

Materials needed

1 Basic supplies (page 10)
2 Torchons
3 Smooth-texture dove grey/beige cardboard
 (46 cm x 66 cm/ 18 in x 26 in)
4 Chalk pastels
5 Red chalk paper
6 Charcoal
7 Fixative spray

THE PALETTE

Here is the recommended palette of chalk pastels from which this picture was made.

1 Yellow ochre	9 Pink
2 Cadmium yellow	10 Ultramarine
3 Cream	11 Light green
4 Light grey	12 Black
5 White	13 Sepia
6 Turquoise	14 Light brown
7 Lilac	15 Burnt sienna
8 Light blue	16 Bright red

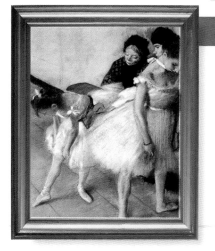

About this painting

☞ *Edgar Degas was encouraged by Ingres to 'draw lines', and he developed a unique style, uniting superb draughtsmanship with a bold and modern use of colour. Interests in everyday life, movement and spontaneity led Degas into the theatres and ballet schools of Paris to record 'snapshots' with both pastel drawings and the new medium of photography. The specific format of the camera viewfinder became a key interest, and he experimented with new compositions and cropped viewpoints as shot through the lens.* The Dance Examination *(1880) is a pastel drawing that deliberately emulates the accidental cuts of a photographic print. The peering examiners are crowded into the corner by the truncated limbs of the girl moving out of the frame, and full focus falls on the dancer stretching forwards into a point.*

① PREPARING THE PAPER

Prepare the template using the grid on page 147. Transfer the drawing to the cardboard using the red chalk paper, and then bolster your outline with charcoal. Select a thin stick or use a charcoal pencil that can be sharpened easily.

Keep your drawn line as accurate as possible in imitation of Degas' master draughtsmanship. Be prepared to correct any lines that do not look right.

At this point just concern yourself with covering the surface.

② BLOCKING IN THE BACKGROUND

The first task is to boldly block in the walls with yellow ochre and cadmium yellow. Do the same for the floors with light grey and cream.

Are your tones and colours correct? Make sure that the floor and walls are properly blended, as it will be hard to revisit them once the figures are blocked in.

③ BLENDING

Blend the separate colours of the floor and walls with your finger to create the flatter background tones. Use a torchon to blend more accurately near the outlines.

Painter's Pointer

Take care not to overblend with pastel and rub away the beauty of the mark. Degas always balanced smoothness of detail with the energy of the painted stroke.

DEPICTING THE DRESSES ④

The full netted skirts are tightly ruched. To achieve this with your pastel, work directional linear strokes from waist to knee along the length of the skirt in white, turquoise, lilac and light blue.

5 EXPRESSING THE SUBTLETIES

Having filled in the dresses, smudge the lines sensitively with your fingers, being careful to allow individual strokes to show through.

Directional strokes describe the shape and texture of the garment.

The dancers' skins are not just pink, they contain many hues depending on the light that is present. Be confident with these slightly unusual combinations, knowing that they are tried and tested!

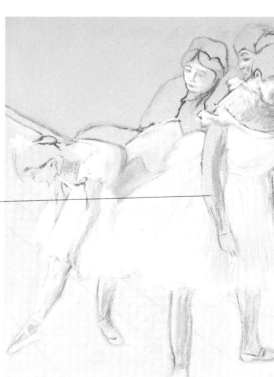

If necessary, draw extra strokes onto the blended skirts to re-emphasise their gathered characteristic.

FLESH TONES ⑥

As the light falls, the full range of varied tones becomes apparent. Describe them using pink, cream, lilac and occasionally light grey. Where shadows are evident, apply ultramarine and light green. Use colour freely and without blending at this stage.

CONTRASTING THE FIGURES ❼

The examiners' presence is darker, less dainty than the dancers. Work them into the drawing with a combination of black, sepia and light brown. Blend the flesh tones on all figures, too, and check anatomical correctness against Degas' version.

Burnt sienna has been used for the hair, lightening with yellow ochre and white and darkening with sepia.

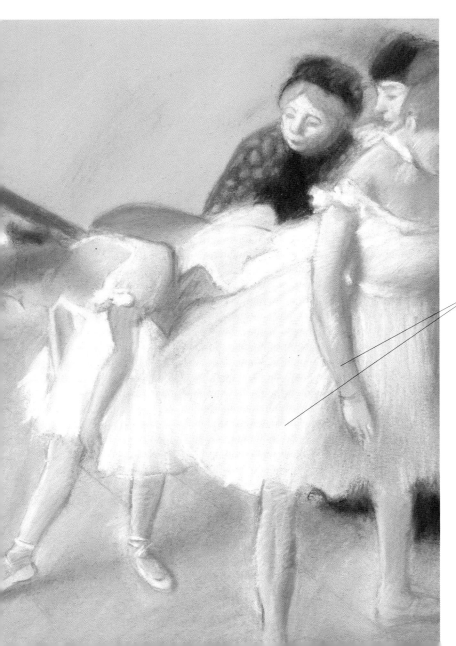

White strokes accentuate the light falling on the pleats of the skirt. A hint of red on the arm or leg echoes the colour found on the cheeks or neck, which reflect the fall of light on the walls.

❽ ADDITIONAL SHADOWS AND HIGHLIGHTS

Bring your version of *The Dance Examination* to fruition by intensifying the floor shadows with selected colours of yellow ochre, burnt sienna, light green and light grey. Add brightness to the back wall with yellow ochre and bright red. Introduce extra modelling to the faces and shoes and add touches of light green to the dresses.

L'ABSINTHE

Degas

E D G A R D E G A S *1 8 3 4 – 1 9 1 7*

Before you begin . . .

Edgar Degas was known to have distanced himself from women, and it is perhaps curious that at times he painted them with such delicate fascination. Even though the marks in the painting are mainly quite raw and edgy, there is tenderness – almost compassion – expressed through the facial strokes. To achieve both levels of mark-making, you will require both flat and round bristle brushes, and a small sable brush for the finer detail in the features. The palette remains more limited than those of Degas' Impressionist contemporaries. Here, oil is substituted with the more rapid drying acrylic, which should aid your speed and quality of mark.

Materials needed

1 Basic supplies (page 10)
2 Medium-texture (284-g/10-oz) duck cotton canvas (46 cm x 61 cm/18 in x 24 in)
3 2B pencil
4 Acrylic paints
5 Brushes: bristle flats and rounds (Nos. 6, 8, 10, 12)/sable round (No. 4)
6 Red chalk paper

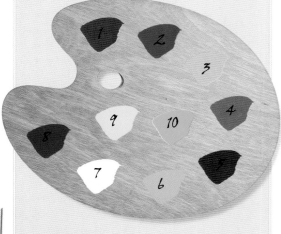

THE PALETTE

The low-key neutral palette of beiges, browns and white works well in projecting the sombre mood of the piece.

1	Burnt umber	6	Yellow ochre
2	Raw umber	7	White
3	Flesh tint	8	Violet
4	Burnt sienna	9	Cadmium yellow
5	Payne's grey	10	Bright green

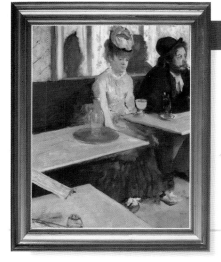

About this painting

☛ *The casual, almost voyeuristic approach to capturing the moment in a deliberate, photographic-style snapshot led to misunderstanding for Edgar Degas. L'Absinthe caused offence when it appeared in London in 1893, through its revelation of the unromantic side of Parisian life. It shows a man and a woman seated next to each other but separated by their own isolation. The woman's full glass of potent absinthe suggests that she is drowning her sorrows. Allegedly, this was not so — she is merely lost in thought! It is a clever compositional piece, with the asymmetrical cropping of the figures enhancing the strong diagonal table-top device that directs the eye back to these sketchily brushed characters. The faces are more detailed, giving them the leading part in this moody late-night play.*

❶ TRACING THE OUTLINE

Prepare the template using the grid on page 148. Use your pencil to push the outline down onto the canvas with red chalk paper. Strengthen the lines with your No. 4 sable, applying burnt umber with its point. Prime the canvas with a thin wash of raw umber and flesh tint.

The extra line keeps the drawing visible through the primer.

Painter's Pointer
Degas did not paint on site, preferring the studio to recollect memories and rework ideas, using studies and photography. The end result, however, always carried a sense of casual immediacy.

❷ SCUMBLING DARK AREAS

The hue used for this technique is predominantly burnt sienna. This is roughed in gesturally onto the bench and dress and darkened down with Payne's grey and raw umber.

Brown sets a dark base to work against with the other colours.

Table tones are echoed in the mirrored reflection of net curtains behind the figures. Grey and small amounts of yellow ochre and violet are used.

DESCRIBING THE FURNITURE ❸

No white in this study is pure. The shabbiness of the interior is characterised with the tables painted in white, yellow ochre and flesh tint, breaking the flatness with white scumbled over the surface when dry.

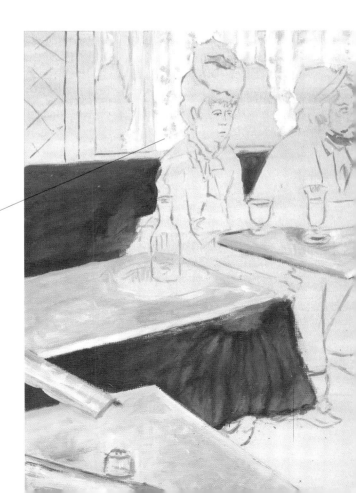

DETAILING THE ROOM ❹

Although the picture is not highly detailed, small features set the scene and need to be included with a finer brush. Mirror reflections, the gilt surround and wallpaper employ the same colours as in the previous stage.

The ochre-grey floor is mixed directly onto the canvas with a dry-brush technique.

❺ DENOTING THE MALE DRINKER

Once again for that sense of immediacy, work in the details of the figure directly onto canvas, using burnt umber and Payne's grey.

PAINTING THE HAT ❻ AND COSTUME

The hat perches solemnly on the front of the lady's head. It is just a little deeper in tone than the curtains behind, so use white, flesh tint, Payne's grey, plus small amounts of yellow ochre and cadmium yellow to describe it and the top half of the dress.

When painting the garments, try to let the strokes of the brush follow the creased material, which in turn follows the body shape.

Let broken colour show through the brushstrokes from the layers underneath.

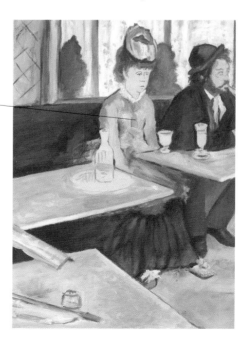

Painter's Pointer
Be spare with your colour and application of paint. The success of the picture relies on considerable understatement to accentuate the important, detailed areas of the composition.

The bottle, tray and glasses harmonise with the surroundings, emphasising the absinthe before the female drinker. Use the same colours as in the previous stage.

ADDING THE DRINKS 7

The key to the whole narrative is the absinthe. This minty colour is simply white with a smidgen of bright green.

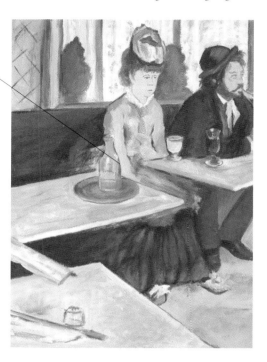

Payne's grey and a fine brush give clarity to any soft surface edges.

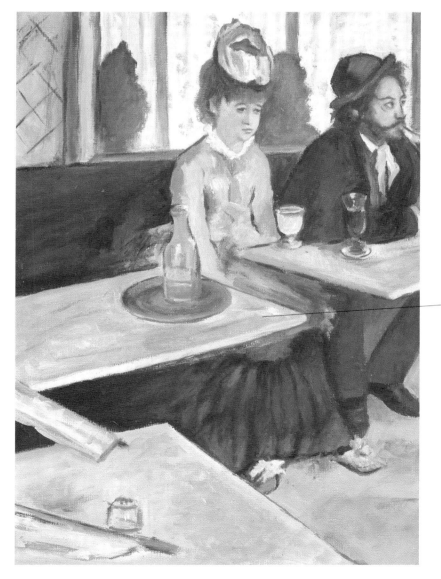

8 PAINTING THE FACES

By leaving the faces until last, you can determine the level of intricacy required when judged against the other parts. Carefully add in the facial tones with a fine brush. The subtle hues of flesh tint, white and Payne's grey give pallor to their complexions, with minute blends of burnt sienna added to the cheek and underside of the jaw.

HANDS OF THE APOSTLE

ALBRECHT DÜRER *1471–1528*

Before you begin . . .

This drawing cannot be rushed. It is a test of patience and your willingness to indulge in the craft of fine draughtsmanship. It is believed that Dürer prepared his paper with a blue wash to emulate the natural blue Venetian paper, of which he had run out. Working to actual size (28 cm x 20 cm/11 in x 8 in) is recommended. A cream weave-textured paper will provide an excellent support with just enough texture to ease the movement of the gouache and watercolour over its surface. It is suggested that you

stretch the paper onto a drawing board (MDF or plywood is best) by wetting it in the sink and attaching it to the board with brown tape. Start only when it is fully dry.

Materials needed

1 Basic supplies (page 10)
2 Cream weave-textured paper (28 cm x 20 cm/ 11 in x 8 in)
3 Watercolours
4 Gouache tubes
5 2B pencil
6 Brushes: sable rounds (Nos. 2, 4)/large sable /synthetic flat (No. 12)
7 Sponge
8 Red chalk paper

THE PALETTE

A minimal palette is required for the Dürer study. Colour was the least important consideration in the artist's intention of understanding the complexities of form.

1 Ultramarine
2 Payne's grey
3 Violet
4 White gouache
5 Black

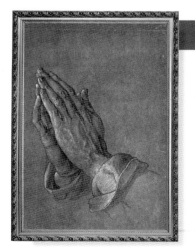

About this painting

A goldsmith's son, Dürer clearly inherited his father's refined talent. He was apprenticed in the techniques of his trade in 1486 by Nuremburg's leading painter and book illustrator, Michael Wolgemut. An extensive traveller, Albrecht Dürer was influenced by the work of Da Vinci, Bellini and Mantegna, and also by contemporary thinking on key issues, such as perspective, which he introduced to artisans in Northern Europe. In Hands of the Apostle, Dürer seeks an inner awareness that is perfectly contained within the outer form of the hands gently meeting. Drawn in 1508, it was a study for the apostle who, in the painting The Hellar Altar, kneels to the right of the picture. Executed on a blue ground, the exquisite finesse of the linear strokes give it the effect of a fine pen drawing. A masterful answer to any artist's prayer!

① TRACING THE OUTLINE

Prepare the template using the grid on page 149. The detailed image needs to be traced onto the cream weave paper using red chalk paper. Use a 2B pencil to firm up the lines.

Sensitive pencil strokes must be added that follow the form.

Prepare the template using the grid on page 149.

Painter's Pointer

Like all parts of the body, hands need to be well observed and drawn. Redo any marks that are not quite right, and always refer back to the original.

② ADDING THE BACKGROUND TINT

Lightly sponge an overall tone of ultramarine over the whole paper to reveal its texture.

ADJUSTING THE INTENSITY ③

Building the full intensity of blue with thin layers is the best way to gain the correct tone. Allow each layer to dry before applying another. Sponging is the best method because it will simulate the process of aging.

DESCRIBING FORM WITH LINE ④
Using your No. 4 brush, lightly skim the pencil outlines of the hands with washes of ultramarine.

⑤ **STRENGTHENING THE IMAGE**
Darken these lines with a mixture of Payne's grey and ultramarine to render greater form.

Check the consistency of the blue wash on a 'tester' sheet of paper before you proceed.

With the addition of shadows, the drawing is given the illusion of emerging from within a three-dimensional space rather than a flat piece of paper.

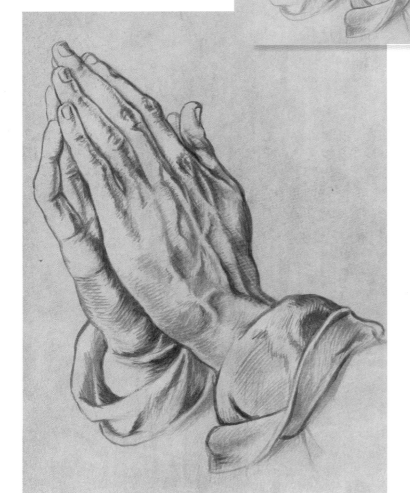

FURTHER SOFTENING ⑥
Gently blend the tones on the hands and in the folds of the sleeves, and warm the resulting shadows with a little violet added to the grey and blue hues. For this, use the large flat brush.

Painter's Pointer

Copying Old Master drawings like Dürer's is especially satisfying. The skill necessary to render a faithful reproduction is one that you can acquire with plenty of practice in his methodology.

7 ADDING THE HIGHLIGHTS

Create a greater sense of three dimensions by drawing additional highlights with a fine sable brush. Using opaque gouache from the tube with a tiny bit of water, stroke around the form with the paint using the traditional crosshatch style.

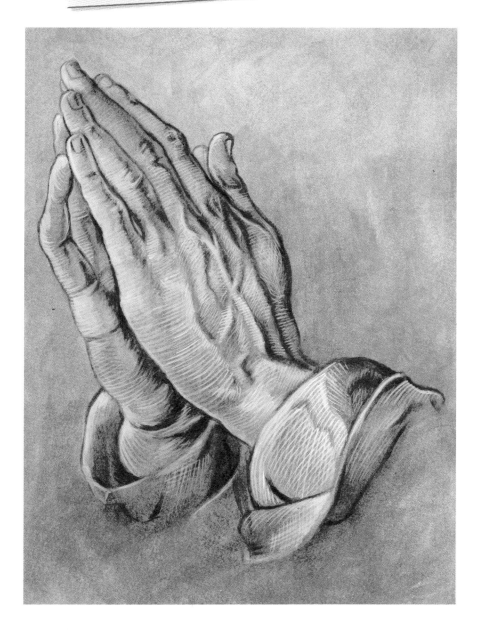

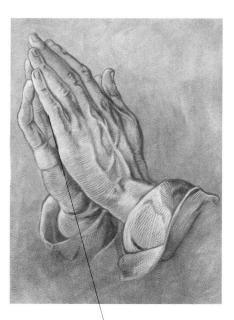

The soft, dark modelling around and in between the fingers impresses a sense of solidity on the praying hands.

8 FINISHING TOUCHES

Check your work of art against the original, all the time looking for overall balance in the use of dark, middle and highlight tones. Add a little black to the blue shadows with a fine sable to give the study greater authority.

TWO TAHITIAN WOMEN

S. Gauguin

PAUL GAUGUIN *1848–1903*

Before you begin . . .

One of the main challenges in re-creating this painting is to achieve the imposing effect of Gauguin's own vision of nature as manifested through stylised flattened shapes and intensely exotic colours, while retaining the subtleties of the women's poses and delicately modelled forms. The painting is suffused with warmth and blazing tropical sunlight. You will need to select and apply your colours with care to achieve such intensity of effect, avoiding muddy colours in the finished work. Gauguin often worked on heavy sackcloth, so a coarse-textured canvas is suggested. Prepare it with a thin wash of raw umber and burnt sienna. As well as a selection of bristle brushes, include a fine sable or synthetic brush for painting in the sinuous outlines of the main elements.

Materials needed

1 *Basic supplies*
(page 10)
2 *Hessian canvas*
(41 cm x 61 cm/
16 in x 24 in)
3 *Acrylic paints*
4 *Brushes: bristle flats*
(Nos. 6, 8, 10)/sable
round (No. 4)
5 *Red chalk paper*

THE PALETTE

The archetypal Gauguin palette is delivered here. Brilliant primary hues are made subtle by quieter mixes of lighter ready-made tube acrylics on a base of earthy browns.

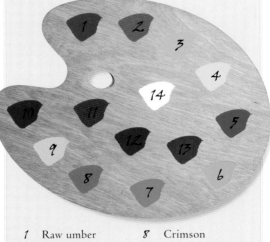

1	Raw umber	*8*	Crimson
2	Burnt sienna	*9*	Light green
3	Yellow ochre	*10*	Violet
4	Cadmium yellow	*11*	Burnt umber
5	Phthalo green	*12*	Ultramarine
6	Bright green	*13*	Cadmium red
7	Cerulean blue	*14*	White

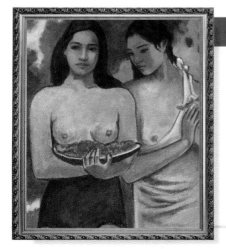

About this painting

☛ *Gauguin found paradise far away from French shores. He lived in Polynesia for two long periods during his life. Staying first on Tahiti from 1891 to 1893 and then returning again in 1895, he remained on Tahiti and on the Marquesas Islands until his death in 1903. Two Tahitian Women was one of many studies that eulogised this native race and the simplicity of their unspoiled lifestyle. There is a strong probability that the woman on the left is his mistress, Pahura. The painting displays characteristics in common with many of his other images of Tahitian life, and he wrote with admiration of 'the erect stature, broad shoulders and strength with grace' of these women. As statuesque forms with enigmatic expressions, dashed with vivid tropical colours, their effect is intoxicating and mysterious.*

❶ PREPARING THE CANVAS

A coarse-textured canvas should be primed with a very thin wash of raw umber and burnt sienna. To simulate the look of unprimed hessian canvas, remove all excess paint with a sheet of paper towel.

Gauguin's vision of paradise is essentially re-created on a coarse-grained texture with a warm primer.

Strong lines are a major force behind the appeal of his South Seas work and are clearly inspired by Japanese prints.

❷ LAYING THE OUTLINE

Prepare the template using the grid on page 150. When the wash has dried, trace the outline of the template using red chalk paper. Go back over the lines to accentuate the elements.

Thorough preparation is vital before painting. The clarity of line will make the application of paint much easier.

REINFORCING THE LINE ❸

Increase the weighting of the figures in the composition by further strengthening the line around them in a wash of burnt sienna, using a fine sable brush.

④ CREATING THE BACKGROUND

Block in the broader shapes of foliage behind the figures with tones of yellow and green. The basis for these hues are yellow ochre, cadmium yellow, phthalo green, bright green and a little cerulean blue.

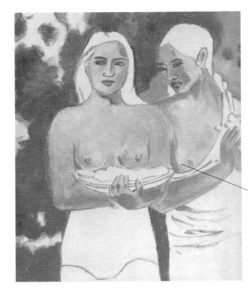

⑤ PAINTING THE FIGURES

The distinctive warm brown skins of the native girls that Gauguin painted are made up of cadmium yellow, yellow ochre and crimson working against complementary shadows of light green and violet. Dab in these areas with a medium-sized flat-bristle brush.

Green is not the obvious choice for darker skin tones, but it is used to great effect as the complement of the reds already included in the lighter flesh shades.

The blending of the greens and yellows sets up a simple decorative, mottled pattern.

Painter's Pointer

Build up thin glazes of colour, mixed freshly on the canvas to allow the canvas texture to show through.

The blossoms jump out of the picture in their vibrancy. Paint them in with cadmium red, highlighted with white.

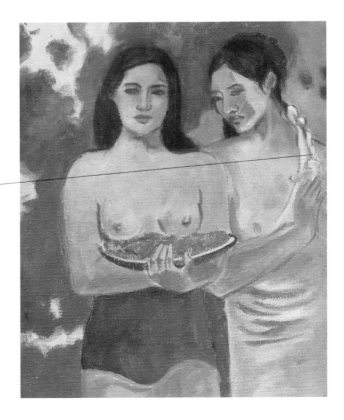

⑥ DESCRIBING THE HAIR AND GARMENTS

The thick, dark hair is built up with soft glazes of burnt umber, yellow ochre and burnt sienna. The upper part of the sarong of the woman on the left is ultramarine and cadmium red, the lower part cadmium red, violet and white. The dress of the woman on the right is a mix of cerulean blue, light green and white. For the melon flesh, apply cadmium red, deepened in selective areas with crimson. Phthalo green mixed with a little violet will present the dark underside of the outer skin.

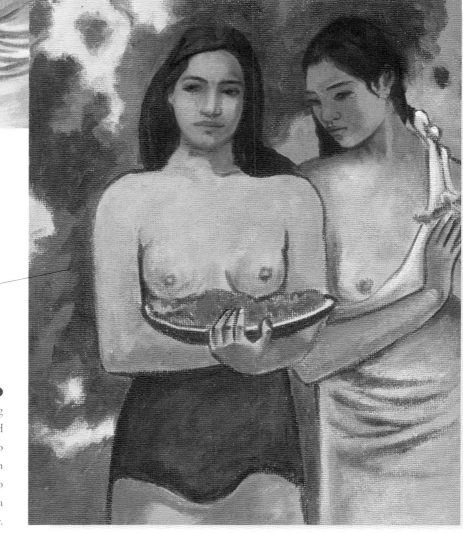

7 EXTRA SHADOW TONES

Take a small round-tipped sable brush and model more detail into the hair and faces. Concentrate especially on adding more green to the contours and the shadow areas, for example, in the recess under the chin and around the hairline and eyes.

Spend time copying the dreamy gaze of the girls, especially the one on the left, looking slightly out of the frame. They provide the main focal point of the whole composition and set up the calming mood.

Establish a darker tone on the left of the picture by adding brownish washes to the crimson.

FINISHING TOUCHES 8

Give added power to the image by bolstering the darker greens of the background foliage with ultramarine mixed with phthalo green. Still using your fine brush, darken the outlines of the girl on the left to increase her prominence. Add extra detail to the folds of the drapery.

STREET IN TAHITI

S. Gauguin

PAUL GAUGUIN 1848–1903

Before you begin . . .

Separating the major forms and shapes and keying them into correct colour choices will be your main consideration when painting this landscape. The marks used vary enormously, from the short flecks of the leaves to the larger, layered passages of sky. A range of flat-bristle brushes will equip you for filling in most of the canvas; smaller round sable brushes will take care of the detail. Gauguin often used rough sackcloth and exploited the matt surfaces with thin scumbles and thinly brushed-on pigment when he had no money or could not get paint. Choose a coarser canvas to achieve his paint techniques, and allow the canvas to show through as you apply the glazes thinly.

Materials needed

1 Basic supplies (page 10)
2 Hessian canvas or coarse-texture (227-g/8-oz) duck cotton canvas (61 cm x 46 cm/ 24 in x 18 in)
3 Acrylic paints
4 Brushes: bristle flats (Nos. 6, 8, 10)/sable rounds (Nos. 4, 6)
5 Red chalk paper

THE PALETTE

The palette is more sombre than you might expect to see in a typical Gauguin oil.

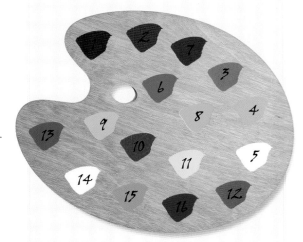

1	Payne's grey	9	Sap green
2	Burnt umber	10	Cadmium red
3	Crimson	11	Cadmium yellow
4	Yellow ochre	12	Burnt sienna
5	White	13	Lilac
6	Cobalt blue	14	Lemon yellow
7	Violet	15	Raw sienna
8	Bright green	16	Ultramarine

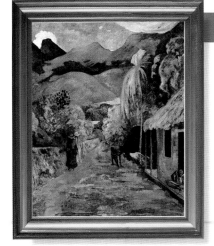

About this painting

☞ *Painted in the year of Gauguin's arrival in Tahiti, 1891, this can be viewed as a recorded glimpse of a new culture. Firmer in detail and more literary than the works of the Impressionists, it nevertheless focuses great importance on the use of bold complementary colours. But like Cézanne, the artist looked beyond the surface quality to more considered solid structures of good composition.* Street in Tahiti *is a landscape of grandeur with the long, pink path converging into an intense red patch distanced at the foot of strange, smooth hills. The tree forms are equally strange, mutating into the dark background, with nebulous white cloud hanging above — all adding to the mystery of the scene. Movement is balanced against stillness and polarises our view between the walking figures and a pensive woman in her doorway looking our way.*

① PREPARING THE CANVAS

Prepare the template using the grid on page 151, and trace the image onto the canvas. Prime its surface with off-white acrylic (mix a tiny amount of raw sienna with white).

The white of the clouds is not layered in the same way but applied with almost full opacity.

Strengthen the lines with a thin mix of Payne's grey and burnt umber.

② APPLYING THE BACKGROUND

Loosely scumble the mysterious pinks and purples of the hills with hues of crimson, Payne's grey, yellow ochre and white.

Blend these tones with a medium flat-bristle brush to create smooth, airy cloud forms.

③ ADDING THE SKY

Take cobalt blue, white and a little yellow ochre and violet as the principal hues making up the sky. Fill it in from right to left, building up the fleeting strokes in a diagonal direction. To achieve this, use a small or medium flat-bristle brush.

Painter's Pointer

Selecting a picture with strong coloured shapes is an excellent way to learn about the organisation of space, colour and composition. Learning from the masters makes composing your own much easier.

④ WORKING IN THE FOLIAGE

Using a lightly loaded brush, roughly block in all the green areas with bright green and sap green.

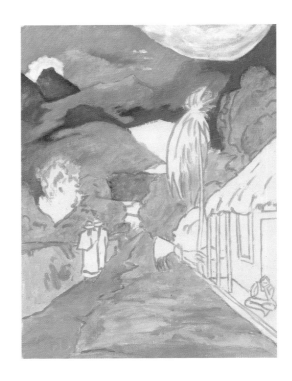

SUPPORTING WITH ⑤ EARTH COLOURS

Add earth colours to the pathway and the bare patches on the grass using a mixture of yellow ochre, cadmium red and white.

The off-white primed canvas shows through in places where the green is at its thinnest.

Some of the trees are warmed by the South Sea light in cadmium yellow.

REFINING THE FOLIAGE ⑥

A small brush is the best tool to define the masses of green space on the canvas. Add white to sap green to give the shrubs in the middle distance a set shape. To achieve a more dappled effect, especially in the darker, shadowy regions of the painting, blend in soft strokes of burnt sienna and Payne's grey.

7 **PAINTING THE THATCHED HUT AND PALM TREE**

The sharp perspective line of the receding dwelling helps create the strong sense of depth evident in this picture. The lean upright palm is a pivotal device for connecting the ground to the sky. To make it prominent, brush the fronds with lemon yellow, raw sienna and bright green. To contrast, paint the trunk in ultramarine and white.

Balance the centre by applying dabs of lilac, crimson and white to the bush on the left of the picture. This complements the palm and ties into the sky.

Adding more detail and a strong Payne's grey outline to the figures and the mule satisfactorily completes this picture.

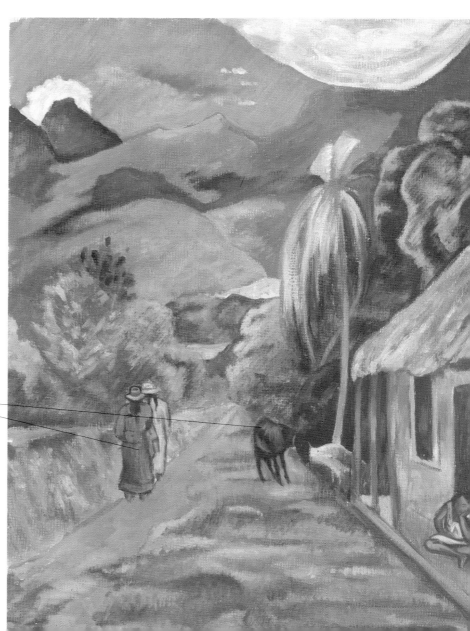

DETAILING THE FIGURES **8**

These echo the bush, also being rendered in the warm combination of ultramarine, cobalt blue, burnt sienna, burnt umber and white. Add any final details to the foliage now, with a No. 2 sable brush.

NIGHTHAWKS

EDWARD HOPPER

EDWARD HOPPER *1882–1967*

Before you begin . . .

Deriving influence from the Ashcan School of realism and French Impressionism, Edward Hopper's work displays a sensitive balance between a low-key palette of painterly strokes and the harder-edged modelling of careful brushwork. This painting deserves a closer look before you start and will provide you with all the vital clues. Look at how the light is contrasted — the relationship of the greens and yellows to each other and the reds — and home in on the techniques he used in building the faces of the figures. The canvas shape is cinematic — a long rectangle — and a primed stretcher, or one in similar proportion, is needed.

Materials needed

1 Basic supplies (page 10)
2 Medium-texture (284-g/10-oz) duck cotton canvas (76 cm x 152 cm/30 in x 60 in)
3 Acrylic paints
4 Brushes: bristle flats (Nos. 2, 4, 6)/bristle rounds (Nos. 4, 6)/fine sable rounds (Nos. 2, 5)
5 Red chalk paper

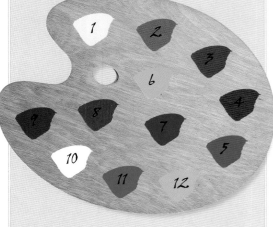

THE PALETTE

The Hopper colours are restrained and sedate, and the deep blues and greys predominate over the warmer reds and creams, which are used sparingly.

1	Cream	7	Prussian blue
2	Burnt sienna	8	Cadmium red
3	Burnt umber	9	Ultramarine
4	Payne's grey	10	White
5	Phthalo green	11	Cobalt blue
6	Sap green	12	Yellow ochre

About this painting

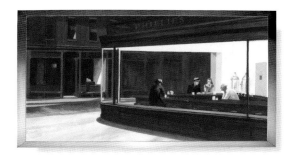

☛ *Hopper's favourite themes of the alienation and isolation of urban existence are set against a backdrop of electric-lit interiors and long shadows; his lone figures often stand in shady corners disseminating a sense of uneasy expectation.* Nighthawks, *1942, is an interesting example of human loneliness, the dispassionate observation of four individuals inside a diner, apparently unconcerned with one another's business. The depiction is at once welcoming and foreboding. The warmth of the rich green and cherry-coloured interior is undermined by the harsh yellow of the fluorescent lighting. The cage-like rendition of the windows is a masterpiece of composition, which filmically cuts our view to the closer edit.*

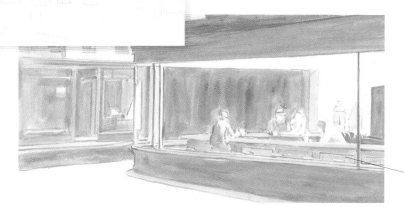

❶ LAYING THE OUTLINE
Prepare the template using the grid on page 152.
With red chalk paper, trace the outline image onto
a cream-painted canvas (use emulsion or acrylic).

❷ ESTABLISHING TONAL DEPTHS
Wash in the medium and darker
tones using diluted burnt sienna
acrylic. Apply your washes with
subtlety, being careful to make the
tones of the diner stronger than
those of the shopfronts behind.

*Contrasts are shown
even at this early stage.*

LAYERING THE SHADOWS ❸
To give a definite appearance of depth,
the shadow areas inside the windows,
across the shopfronts and on the
hoardings should be built up in thin
layers of burnt umber, phthalo green
and Payne's grey using a flat brush.

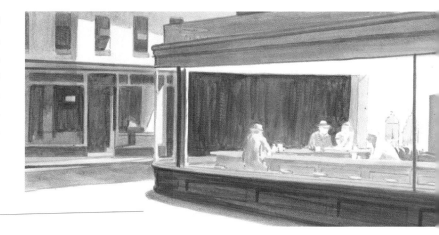

*The lightest parts of
the picture are the
bare cream canvas
showing through.*

*At this stage you
can add a Prussian
blue wash to the
characters, too.*

ADDING LOCAL COLOUR ❹
A blue-green wash over the road,
sidewalk and shopfronts reflects
through the restaurant glass and can
be painted using a mix of sap green
and Prussian blue. In complementary
contrast, use cadmium red in the
upper storey of the background shop.

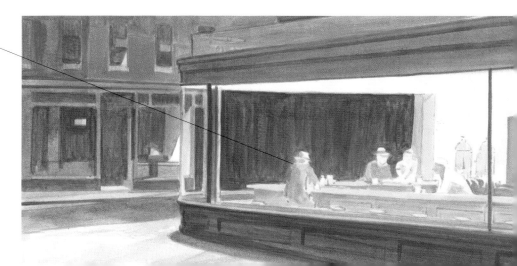

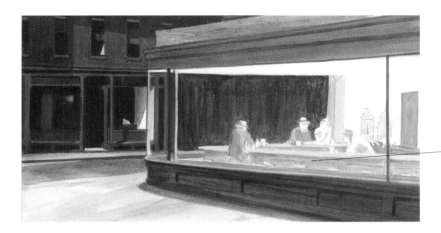

5 ENRICHING THE PAINTING

All the colours of the background shops are strengthened and refined by overlaying the basic palette in a repeat of stages 3 and 4, with a medium sable round brush (No. 6) and a finer one for more intricate details.

When it is dry, stand back and assess the spatial relationships of the elements. Are the tonal values creating the correct illusion of depth?

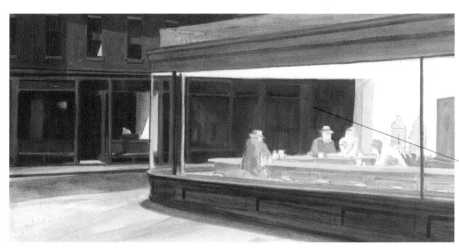

6 RECEDING THE BACKGROUND

Shadows from buildings, above and around, conveniently mask the façades of the background shops, making them recede yet further. For this, add in a deeper tone of Payne's grey with ultramarine.

Even in the darkness, detail is still visible.

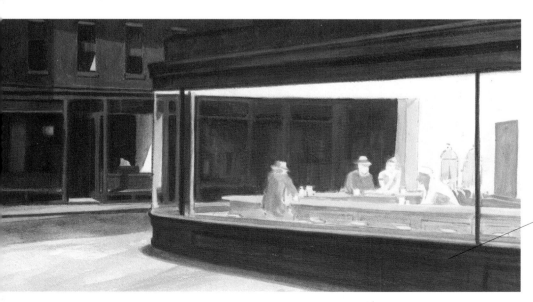

7 DETAILING THE DINER

The outer walls are silhouetted with Payne's grey and burnt sienna, and a fluorescent sheen is laid transparently with a combination of white, cobalt blue, phthalo green and Payne's grey.

Continue to build the paint up in thin transparent layers.

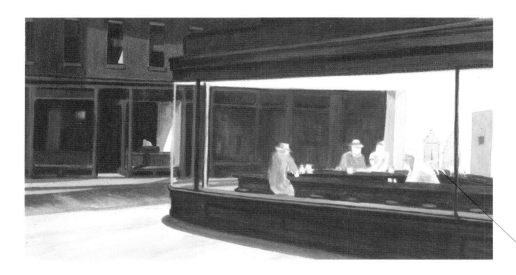

8 PAINTING INTERIOR SURFACES

With all of the outside work almost complete, take your finer sables and pick out the details of the bar surface and panels on the inside of the restaurant with burnt sienna and burnt umber together. The definition edges that border the right-hand side of the composition should be established with flat strokes of yellow ochre.

Take time with your painting of details. Because there are so few in Hopper's pictures, they need to convey with accuracy the narrative content of the composition.

9 FINISHING TOUCHES

Turning the people into the main focus of the composition requires due care and attention. Use the finest brush for the lettering on the diner.

For further authenticity, brush thin washes of Payne's grey and phthalo green on the lettering on the hoarding, then systematically add the figures.

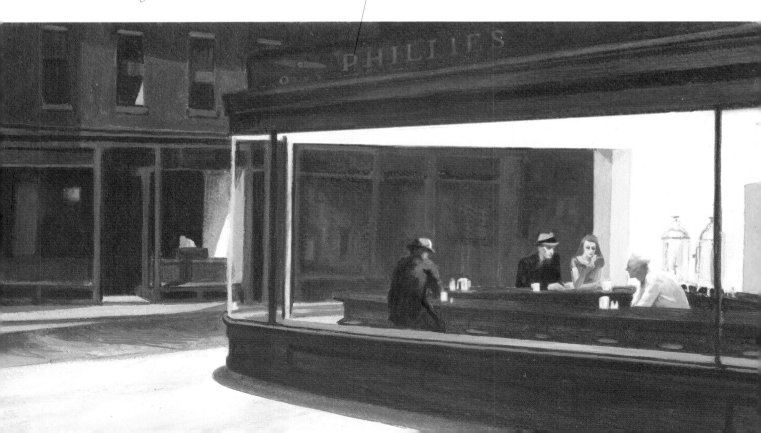

THE KISS

GUSTAV KLIMT *1862—1918*

Before you begin . . .

Don't be daunted by the complex decorative nature of this painting. Apart from the protruding limbs and pale heads of the couple embracing, the painting is essentially a designed surface of stylised patterns and interlocking shapes. If viewed as smaller manageable areas, *The Kiss* can be treated in much the same way as the other paintings in this book. You should focus on the patchwork shapes that make up the sumptuous outer garments wrapping the two lovers together. Look at the relationship of patterns one to another – their order and tonal value – and consider a systematic plan for painting the coloured shapes. You will need a square primed canvas, a set of bristle flats, and a couple of sable or synthetic round brushes.

Materials needed

1 Basic supplies (page 10)
2 Medium-texture (284-g/10-oz) duck cotton canvas (61 cm x 61 cm/ 24 in x 24 in)
3 Acrylic paints
4 Brushes: bristle flats (Nos. 2, 6, 10)/sable rounds (Nos. 4, 8)
5 Red chalk paper
6 Toothbrush

THE PALETTE

The golds are re-created using yellow pigments. Earth pigments predominate across the background of the canvas, and spots of pure colour form the patterning.

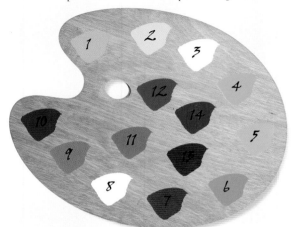

1	Yellow ochre	8	White
2	Cadmium yellow	9	Orange
3	Lemon yellow	10	Ultramarine
4	Bright green	11	Crimson
5	Sap green	12	Lilac
6	Raw sienna	13	Payne's grey
7	Burnt umber	14	Cadmium red

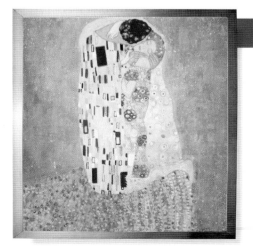

About this painting

☛ *Gustav Klimt's work is a strange unification of Art Nouveau style and symbolism. With his own concepts of harmony and beauty, he steered a unique course through the modern movement of Expressionism. Klimt shunned the conservatively moralistic ethos of the previous generation of artists and exploded into images such as this erotically lush couple emerging in a swirling mass of shapes and patterns from a field of flowers. Their passion is conveyed through Klimt's sensuous handling of line and the richly decadent colour scheme that transports their feelings for each other into the ecstatic realm of their own fantasy. The central placing of the couple in* The Kiss *is compositionally unusual, but works through having the balance offset by the dynamic bending of the lovers' bodies.*

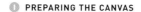

1 PREPARING THE CANVAS

Prepare the template using the grid on page 153. Trace only the main outline shapes onto the canvas with red chalk paper, then block in the main part of the background by applying a mixture of yellow ochre and cadmium yellow.

Leave the central shape as white primed canvas.

Painter's Pointer

Always keep the broader picture in mind. It is hard to imagine the detailed end result at this stage, but thinking about what lies ahead can help you focus on the task.

2 COLOURING THE MAIN SHAPES

Paint in the central shape that will form the costume with cadmium yellow and lemon yellow, and the grassy area in bright green with a little sap green.

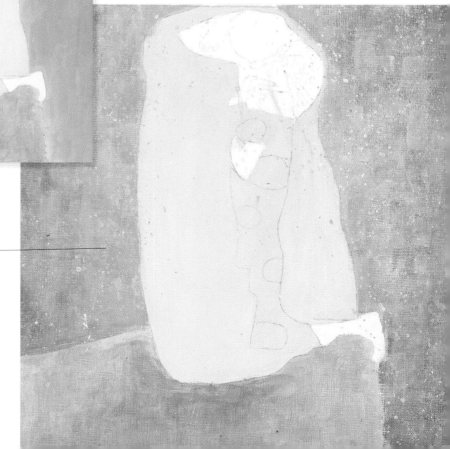

Assess the relationship between the three tonal areas, and adjust if necessary.

TEXTURING THE BACKGROUND 3

Return to the background and darken it down with a wash of raw sienna and burnt umber using a large flat-bristle brush. Add texture by splattering white and lemon-yellow speckles with a toothbrush.

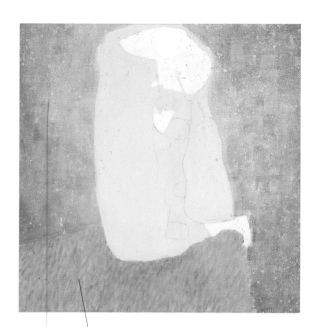

Short strokes turn flat green paint into raised grass.

5 WORKING IN THE DETAILS

Once the green flecks have dried, put flower heads into the lawn. Orange, ultramarine, crimson, lilac and cadmium yellow produce a welcoming array and considerably lighten the tone of the base.

4 ADDING BACKGROUND DETAIL

Flecks of detail in the grass can be included now with a small brush. Dab bright green, sap green and lemon yellow in a vertical direction.

Even the hair must be treated as decorative patterns.

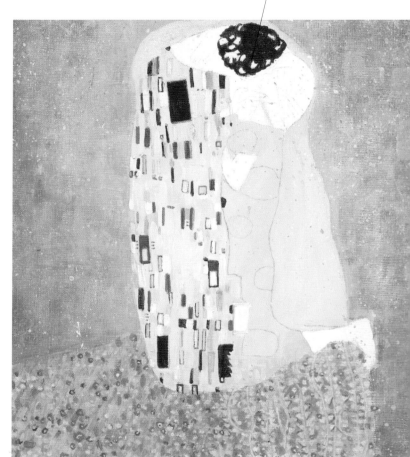

OUTLINING THE MALE FIGURE 6

The hair and costume pattern should now be traced onto the correct space using the red chalk paper. Payne's grey with a little white for a light grey colour, along with Payne's grey, yellow ochre and white make a good combination.

7 OUTLINING THE FEMALE FIGURE

As in the previous stage, trace down the patterns of the dress, the limbs, head and hair. Use a mix of orange and burnt umber on the hair. Describe the clothing patterns with brighter patches of ultramarine, crimson, bright green, cadmium red and white.

Use only fine sable or synthetic brushes for this delicate penultimate stage.

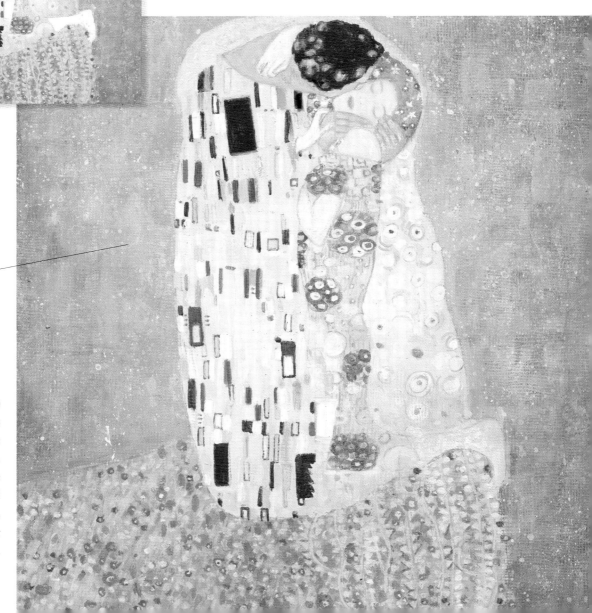

Come back to your picture afresh and compare the original with your own version to see if you need to strengthen or adjust the mark-making.

FINISHING TOUCHES 8

Finally, the faces and hands should be modelled with a fine sable No. 4 brush. To draw attention to the woman's features, add more white into the face, arms and legs, and further outline in pale grey.

LITTLE BLUE HORSE

FRANZ MARC 1880–1916

Before you begin . . .

Typical of art produced at the turn of the 19th century, this study was originally created on a primed white medium-weave canvas. The luminosity of pure colour was caused by light reflecting from its white base through the thin glazes of colour. Buy or make a canvas stretcher and make sure that it has a coat of acrylic primer or white emulsion washed over its surface. Gather a group of round and flat-bristle brushes that can create a range of broad, expressive marks. It is a good idea to take a spare sheet of paper or a waste piece of primed canvas and practise making marks similar to those in *Little Blue Horse*. Be aware also of what happens when you lay stains of one colour on top of another.

Materials needed

1 Basic supplies (page 10)
2 Medium-texture (284-g/10-oz) duck cotton canvas (41 cm x 61 cm/ 16 in x 24 in)
3 Acrylic primer/ white emulsion
4 Spare paper/ waste piece of primed canvas
5 Acrylic paints
6 Brushes: bristle flats (Nos. 8, 10)/ bristle rounds (Nos. 4, 6, 8)
7 Red chalk paper

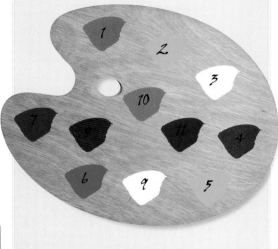

THE PALETTE

Rich, energetic hues of full intensity constitute the very modern palette of the Expressionist artists like Franz Marc.

1	Crimson	7	Ultramarine
2	Yellow ochre	8	Payne's grey
3	Lemon yellow	9	White
4	Cadmium red	10	Cadmium orange
5	Sap green	11	Violet
6	Cobalt blue		

About this painting

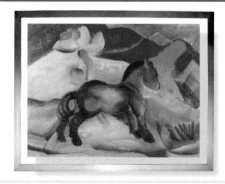

☛ *The German Expressionist painter Franz Marc used his art to promote spiritual values, believing that animals had the ability to commune and harmonise with nature. In 1911 he founded* Der Blaue Reiter *(The Blue Rider), a group of Munich artists named after Marc's love of horses, which included August Macke and Wassily Kandinsky. Promoting the study of children's art and primitive cultures, it had no set artistic manifesto, although its exponents experimented with colour symbolism and paved the way into abstraction.* Little Blue Horse *is one of a series celebrating the austerity of the male through the colour blue. It is set against yellow hills, the gentle, sensual female, and a brutal red sky representing matter, which the other two need to fight against and overcome!*

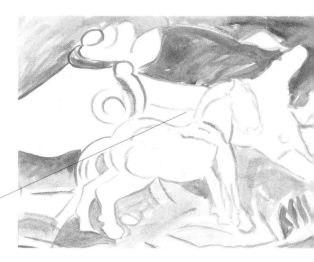

REINFORCING THE OUTLINE ②

Reinforce the simple drawing with crimson using a fine brush, and then block the background in with your broadest flat brushes.

The drawing of the Expressionists was broad, loosely defined, and concerned with shape and movement.

① TRACING THE OUTLINES

Prepare the template on page 154. Trace the basic outlines onto the canvas using the red chalk paper.

Eliminating white canvas increases the confidence and desire to paint.

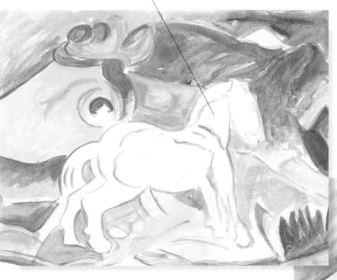

③ BLOCKING IN THE BACKGROUND

Work the background into the canvas in a relaxed way with yellow and green. To make the yellow, mix together yellow ochre, lemon yellow and cadmium red. To make the green, mix together sap green and cobalt blue.

Use the medium-sized brushes to establish three-dimensional tonal variation crudely by thinning the paint down.

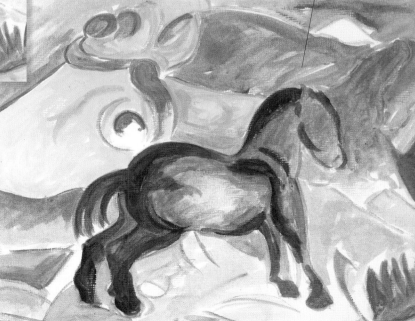

ESTABLISHING THE HORSE ④

Rough the shape of the horse in with ultramarine and Payne's grey.

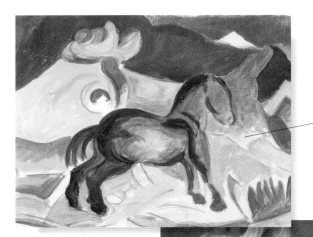

5 STRENGTHENING THE HILLS AND SKY
The distant hills and the apocalyptic sky
are defined by adding a vivid crimson hue.

*Depths within the
picture begin to
emerge as the tonal
variations are created.*

6 BLENDING THE MIDDLE DISTANCE
Using a medium flat-bristle brush and
pigment that is neither too thick nor too
wet, merge the colours so that there are
no hard edges. Building up the layers of
colour in this way will strengthen the hills
and trees of the middle distance. Smooth
the top layer with your finger also.

*Remove the
distractions caused
by rougher paint
strokes, which
upset the rhythm
of the painting.*

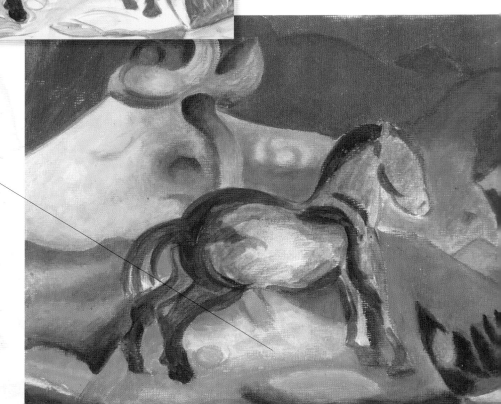

*The lighter foreground
helps to give the
horse prominence
in the composition.*

ADDING FOREGROUND COLOUR 7
The slightly lighter soil beneath
and around the horse is made up of
crimson, cadmium red, white and a
little orange. In total contrast, the
plants are simply sketched in with
cobalt blue, Payne's grey and sap green.

REFINING THE HORSE 8

The horse's hide is worked further with a medium flat brush in a combination of ultramarine, cobalt blue and violet.

Assess the specific areas of the painting, and blend them still further with finger and brush.

9 **ADDITIONAL SHADOWS**

The strong shape of the horse's torso is a feature worth exaggerating, and it portrays the power and presence intended by the artist. The colours for this are Payne's grey and ultramarine. Blend them with your finger.

The finer details, like the tail, ears and mane, are important in finishing your study.

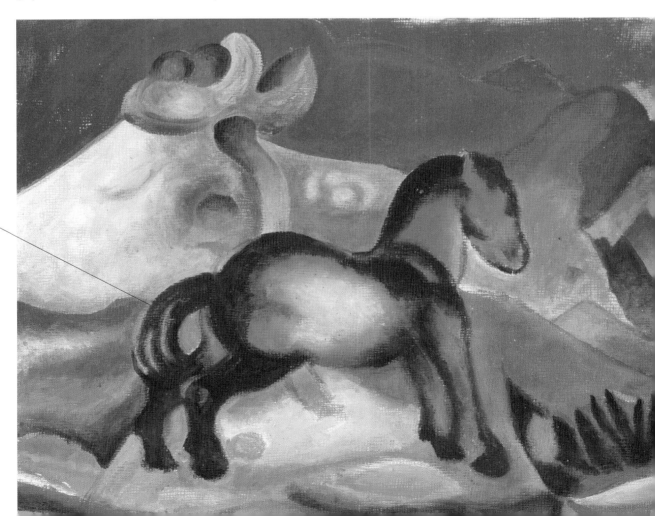

THE GLEANERS

J F Millet

JEAN-FRANÇOIS MILLET *1814–1875*

Before you begin . . .

As you prepare to undertake this painting, bear in mind that Millet worked indoors on outdoor subjects that he sketched from life, drew from memory and realised in the studio. The stiff qualities of paint employed by the artist can be replicated using short flat-bristle strokes in a range of sizes. It is interesting to note that Millet experimented by mixing oil paints with water to imitate nature's effects on surfaces. Fluid transparent browns were washed over a pale ochre ground to produce dark reflections in water, while the surface reflections of sky and the opacity of light were shown with thicker, broken white and blues. Use a spare piece of strong paper/cardboard to practise handling different paint consistencies and variations of mark.

Materials needed

1 Basic supplies (page 10)
2 Smooth-texture (341-g/12-oz) duck cotton canvas (46 cm x 61 cm/ 18 in x 24 in)
3 Spare strong paper/cardboard
4 Acrylic paints
5 Brushes: bristle flats (Nos. 4, 6)/ sable rounds (Nos. 2, 6, 8)
6 Red chalk paper

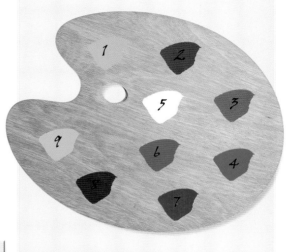

THE PALETTE

A sad painter favours a sad palette to describe his world, with plenty of earth pigments and a tiny selection of very natural colours.

1	Yellow ochre	6	Phthalo green
2	Burnt umber	7	Cadmium red
3	Burnt sienna	8	Payne's grey
4	Cobalt blue	9	Sap green
5	White		

About this painting

☛ *From Parisian revolution to the forests of Fontainebleau, the Barbizon artists sought greater naturalism and a truthful portrayal of the countryside. But Millet was strangely at odds with the self-congratulatory Second Empire France, and depicted ordinary, needy country folk, gleaning the scraps from the plentiful harvest as a basic human right. After many painstaking drawings, Millet painted three women bending low, faces darkened by the sun and silhouetted beneath their own occluding shadow in the fading light of a summer's day. This composition represents two opposing worlds — the golden background, their dreams; the dim foreground, their troubled reality. Millet treats them with respect, celebrates their plight with reverence and gives them dignity.*

PRIMING THE CANVAS ❶
Broadly brush the entire canvas
with a pale wash of yellow ochre
using a large flat-bristle brush.

*Such a detailed example of
realism requires a detailed
underdrawing from the
earliest stage to keep the
composition tight.*

❷ **TRACING THE OUTLINE**
Prepare the template using the grid on page
155. Use the red chalk paper to press down
the traced image, and firm up these outlines
with thin washes of burnt umber.

*Darken the foreground
at the picture's base
with brushy strokes
of burnt umber.*

PAINTING THE FIELDS ❸
Still loading the brush with burnt
umber, drop a textured tone across the
band occupied by the field, and add
warmth with scumbles of burnt sienna.

4 **CREATING THE SKY**

The warm, moody light that typifies this painting will occur with the application of thin coats of cobalt blue and white. Allowing the yellow ochre underpainting to show through is key.

The highlights on the shoulders and arms of two of the gleaners are an important device to draw attention to them.

The canvas displays a strong sense of depth as soon as the sky is painted.

CLOTHING THE FIGURES **5**

With your picture centring on the figures, it is essential that they are carefully clothed. The colours are specific. Paint the left figure with a phthalo green dress, cobalt blue hat and burnt umber top. The centre figure should wear a red hat and sleeves, burnt umber dress and a top of yellow ochre lightened with white. The larger woman on the right stands imposingly, dressed in a Payne's-grey-and cobalt-blue dress and a burnt-umber apron and hat.

6 **TONING DOWN THE CORNFIELDS**

The golden glow of the fields against the sombre figures is overpowering and needs to be toned down with burnt umber, Payne's grey and white. Achieve this with a very dry flat-bristle brush.

Even tones bring the separate elements together in greater harmony.

7 DEFINING THE BACKGROUND

Dabs of specifically placed paint add
an understated detail to the haystacks,
cart, figures and hills in the distance.
Complete this with the pastel shades
of cobalt blue, white, sap green and
yellow ochre, using a fine sable brush.

*Up close, the focused
detail on the
background scene is
simply made up of
small flecks of pigment.*

FINISHING TOUCHES 8

Take this opportunity to strengthen any
areas, especially where the figures need
to show prominence at the front of the
composition. Darken the outlines and
figures with Payne's grey and burnt umber.

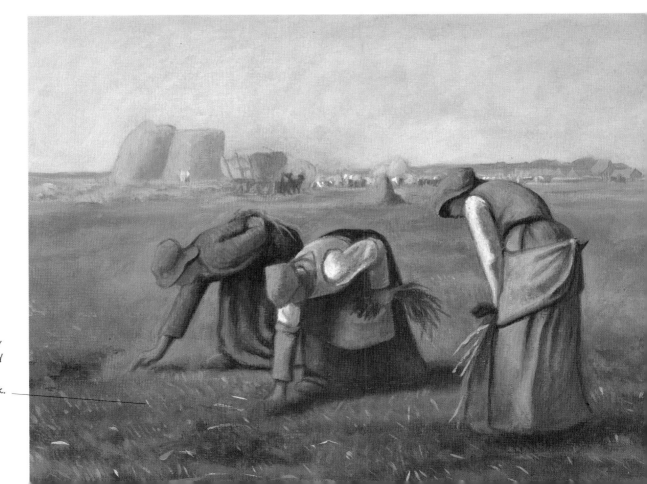

*With a fine sable
brush, occasionally
denote the chopped
ears of corn using
a thin white mark.*

JEANNE HEBUTERNE

Modigliani

AMEDEO MODIGLIANI 1884–1920

Before you begin . . .

The simplicity of elongated forms and the gracefully mannered sophistication of Modigliani's studies provide a refreshing alternative to the typical portrait image. Accurately fitting the simplified shapes into the upright rectangle will test your powers of composition and observation. The passive use of browns and earthy reds will provide you with the perfect opportunity to practise subtle blends with hues of a similar tonal range. Take a good size primed canvas for this project –

46 cm x 61 cm (18 in x 24 in) is very close to the original. You will need a fine sable or synthetic round brush and a medium and large flat-bristle brush for filling in bigger shapes.

Materials needed

1 Basic supplies (page 10)
2 Medium-texture (284-g/10-oz) duck cotton canvas (46 cm x 61 cm/ 18 in x 24 in)
3 Spare sheet of paper
4 Acrylic paints
5 Brushes: bristle flats (Nos. 8, 10)/ sable round (No. 4)
6 Red chalk paper

THE PALETTE

The simple harmony of the browns is keyed to the warm flesh tones, which are heightened by white, yellow ochre and cadmium red.

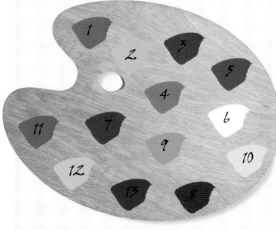

1	Burnt sienna	8	Payne's grey
2	Yellow ochre	9	Raw sienna
3	Cadmium red	10	Cadmium yellow
4	Cadmium orange	11	Phthalo green
5	Lilac	12	Flesh tint
6	White	13	Ultramarine
7	Burnt umber		

About this painting

☞ *A Jewish émigré and artistic 'outsider', Modigliani was attracted to the rich vein of Parisian culture at the turn of the 20th century but never found sympathy with any of its many groups. The work of Modigliani suggests an attraction to the clear, decorative outline of late Gothic and early Renaissance profile portraits, the rich colour of the Venetians and the primitive proportions of African sculpture. His model, Jeanne Hebuterne, was the last partner in a line of stormy relationships, and he came close to marrying her before his untimely death in 1920. Here she nonchalantly cocks her head and rests it on two extended fingers of a hand stretching itself along the vertical line of her elegant neck. The empty eye slits only add to the detachment of this fragile pose, and the wide brim of her hat frames this sentiment.*

① ESTABLISHING THE OUTLINE

To start, trace the image using the template on page 156 onto the canvas with red chalk paper. Strengthen the outline with burnt sienna using a fine sable or synthetic brush. Take a large flat-bristle brush and lay a light wash of yellow ochre, edge to edge, over the whole canvas.

Check the dilution of the wash beforehand to avoid streaky paint.

Stay close to the edge of your outline to maintain the necessary shapes.

Painter's Pointer

Practise blending colours smoothly on a spare sheet of paper before you add the upper layers. With so little detail, erratic brushstrokes could upset the rhythm of the picture.

APPLYING THE BACKGROUND COLOUR ②

Squeeze cadmium red, cadmium orange and a bead of lilac onto your palette, combine them and paint the new colour into the space around the figure. Work it into the canvas to expose the texture, and rub a little white across the surface with your finger.

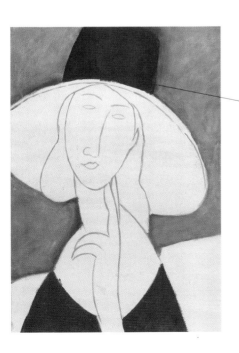

Short strokes give an interesting texture.

③ PAINTING THE COSTUME

Warm the black of the dress and hat with a blend of burnt umber, Payne's grey and burnt sienna. Apply these wet, directly onto the surface.

A fine sable or synthetic brush is best for redefining the brim.

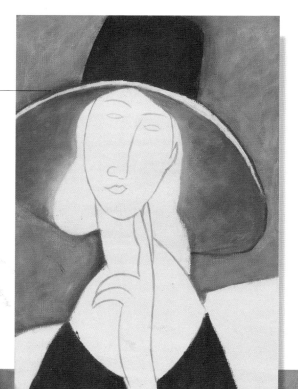

4 **SCUMBLING THE SHADOWS**

Control the movement of your marks gently from the wrist with a medium-sized bristle brush when building the shadows. The hat employs raw and burnt sienna under the brim and is outlined in grey. The brim is highlighted with yellow ochre, white and cadmium yellow.

5 **MODELLING THE FIGURE**

With longer flowing strokes, add the hair in a combination of burnt umber and burnt sienna outlined with Payne's grey. Apply the lower background with a large bristle brush using the subtly receding hues of phthalo green, burnt sienna and Payne's grey.

WORKING THE FLESH TONES **6**

For a rich skin complexion, apply white, yellow ochre, flesh tint and a tiny amount of cadmium red to the face and hand, taking the time to blend them smoothly.

Be aware that the background is of similar tone but of distinguishably different hue.

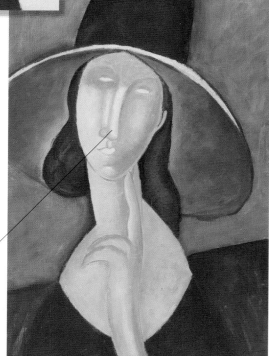

The creamy white highlights are delicately mingled along the edge of the nose.

Painter's Pointer
The smoothness of blending on the skin tones and the fabrics will test your ability to blend evenly without losing the obvious show of short, stroking brush marks.

Just adding these outlines brings the pose to life.

EXTRA DETAILS 7

The features of the face and hands are strengthened with further outlines of burnt sienna. Accentuate the curve of the nose and lift of the eyebrows with singular sweeps of a fine round brush.

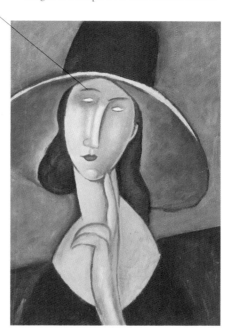

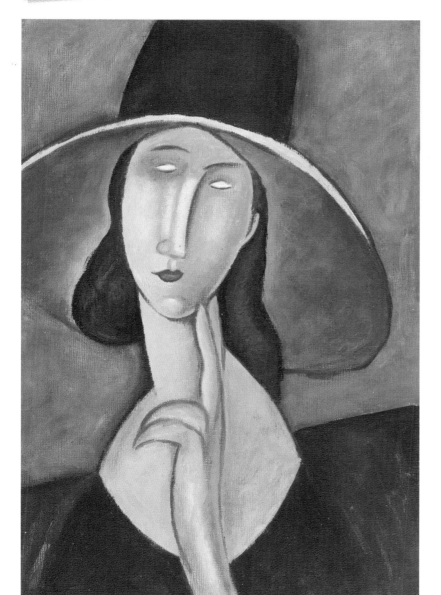

8 FINISHING OFF

Even Modigliani's handling of the finer features, such as the lips, are executed with soft, fusing hues of cadmium red and burnt sienna. The only use of ultramarine can be found in the pale eyes. Step back from the canvas and assess where outlines may need added strength. Apply this with burnt umber and Payne's grey.

WATER LILIES

Claude Monet

CLAUDE MONET *1840–1926*

Before you begin . . .

Imagine the evening light falling on still water, reflections of the sky casting a red tinge over its surface and picking up the floating white blossoms. Just thinking about what you are going to paint can help you understand what you are trying to achieve through the exercise. Monet's use of vertical brushstrokes was more than just a whim. It helped to give cohesion to the melting silhouettes and bright reflections that provide the bottom layer of the painting. The bold horizontal strokes counterbalance the vertical as rows of water lilies move across the distance of the pond. Monet used thick sculptural paint over the thinner watery glazes to achieve the illusion of depth.

Materials needed

1 Basic supplies (page 10)
2 Medium-texture (284-g/10-oz) duck cotton canvas (61 cm x 66 cm/ 24 in x 26 in)
3 Acrylic paints
4 Brushes: bristle flats (Nos. 6, 8, 10)/bristle rounds (Nos. 4, 6, 8)
5 Red chalk paper
6 Green conté pastel

THE PALETTE

Monet's ready-made bladders of rich oil colour are replaced by the modern acrylic equivalent for your master copy.

1	Payne's grey	*8*	Yellow ochre
2	White	*9*	Burnt umber
3	Cadmium yellow	*10*	Phthalo green
4	Flesh tint	*11*	Cobalt blue
5	Crimson	*12*	Lilac
6	Bright green	*13*	Lemon yellow
7	Sap green		

About this painting

☞ *The Impressionist ethos of working outside the studio was to produce in Claude Monet some of the most stunning series of paintings of all time. Surveying the same subject under different lights and weather conditions, the artist captured the innate sensitivities and mysteries of life and committed them to canvas. In 1883 he moved to Giverny, northeastern France, and created a beautiful Japanese-style garden filled with the most gloriously elaborate plants, which were to inspire Monet's work for the rest of his life. With both the artist and garden in full maturity in the 1890s, Monet began his famous water lily series — 18 extraordinary paintings in which the shimmering pond is secondary to the suffused light and atmosphere that envelops it.*

1 PREPARING THE CANVAS

White unblemished canvas can be intimidating, so lightly brush over the surface with a Payne's grey and white diluted wash. Prepare the template using the grid on page 157.

2 TRANSFERRING THE IMAGE

Push the image down onto the canvas with red chalk paper and then strengthen the outlines with a mid-green conté pastel pencil.

Monet favoured light washes to expose the canvas grain.

The conté adds yet another biting texture to the surface and prevents the outline from being submerged by paint layers.

Painter's Pointer

Monet carefully selected sets of similar hues. A typical painting would contain two complementary sets that would react against each other, sparking the dazzling interplay that is typical of him.

BLOCKING IN THE WATER 3

With downward strokes, define the water using cadmium yellow, flesh tint and crimson. These can be blended on the canvas surface with a medium round bristle brush.

ADDING THE LILIES 4

The distinctive oval shapes of
the lily leaves are described next
with a mixture of bright green,
sap green and yellow ochre.

*Add a little extra
definition to the
edges of the lily
leaves with a soft
line of burnt umber.*

*Dabs of white for the
lilies help to separate
the surface objects from
the surface reflections.*

5 REINFORCING THE REFLECTIONS

The silhouetted shapes of the
trees and bushes are added with
phthalo green and cobalt blue and
warmed to harmonise with the
pinkish sky, using lilac.

*Try not to let these
shapes flatten when
applying the paint.
Where the colour
thins in places on the
surface, you will get
subtle tones that
describe the forms of
objects such as trees.*

DETAILING THE LILIES 6

Brush the flower blossoms in pure white
with a little lemon yellow broken in.

7 SOFTENING THE SHADOWS

The misty quality of the reflections and shadows can be softened and blurred by adding small dabs of white, cadmium yellow and Payne's grey with a fairly dry, medium round bristle brush.

FINISHING TOUCHES 8

The final strokes of crimson and cadmium yellow added to the lily flowers will be picked up by the viewer's eye because they stand out from the harmonising colours throughout the composition.

Create the final Impressionist touch with short strokes of white, lilac and grey. Move them in a circular direction to mirror the movement of gently stirred water.

THE CRADLE

Berthe Morisot

BERTHE MORISOT *1841–1895*

Before you begin . . .

Delicacy of touch is the important quality to bear in mind before embarking on this Impressionist gem. The original was painted in oil, but for quickness of drying, acrylic is recommended. Morisot's soft, brushy lines were achieved with a range of round bristle brushes, the largest for filling in background areas, the smallest for delicate details on the subjects' skin. You may also like to use a fine sable brush to pick out highlights in the finishing stages and keep the outlines (where they exist) of faces and hands crisp.

The canvas needn't be primed, because Morisot preferred to allow paint to 'sink' into the fabric, causing each paint layer to look slightly dull, with plenty of canvas showing through.

Materials needed

1 Basic supplies (page 10)
2 Medium-texture (284-g/10-oz) unprimed duck cotton canvas (41 cm x 51 cm/ 16 in x 20 in)
3 2B pencil
4 Acrylic paints
5 Brushes: bristle rounds (Nos. 6, 8, 10)/fine sable round (No. 4)
6 Red chalk paper

THE PALETTE

Morisot's palette contained strong primaries, earth colours and plenty of lights such as flesh, white and ochre. Her very broad strokes, combined with her palette, gave the pictures the look of an opaque creamy mist.

1	White	6	Burnt umber
2	Cadmium yellow	7	Burnt sienna
3	Cadmium red	8	Violet
4	Ultramarine	9	Yellow ochre
5	Payne's grey	10	Flesh tint

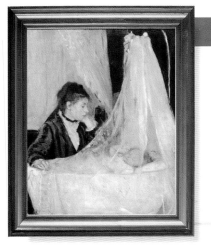

About this painting

☛ *A lady's journal in paint, not words, is perhaps the most suitable description of the work of Berthe Morisot, who, like her Impressionist contemporary Mary Cassatt, was unusually celebrated in the higher echelons of art at a time when women in general had no artistic recognition. She enjoyed an intense and respectful working friendship with Edouard Manet, from which her light, painterly palette was inspired. The Cradle, 1872, shown in the first Impressionist exhibition of the following year, is a tender portrait of the artist's sister watching over her sleeping baby. In a crib of soft netting set against similar curtains, Morisot's dry, flaked brushstrokes are at their most effective, and the composition carefully contrasts the soft, protected world behind the curtains with the mother's outer world of protecting.*

1 OUTLINING ONTO CANVAS

Prepare the template using the grid on page 158. Trace the image onto the canvas with your red chalk paper and, with a reasonably sharp pencil, reinforce the image. Next, begin blocking in the areas of white netting and cradle with strokes of white mixed with smaller amounts of cadmium yellow, cadmium red, ultramarine and Payne's grey.

2 ADDING THE DARKS

The chair and wall are the darkest parts of this painting, keeping compositional tension between bottom and top corners. Scumble them in with burnt umber and burnt sienna.

The brushstrokes on the netting move mainly in a vertical direction.

The lacework is not overfussy, but kept to simple tonal areas denoting the folds.

Keep the strokes on the dress simple, and make sure that they follow the general vertical direction of the work.

MODELLING THE DRESS 3

The next darkest tonal value in the painting is the woman's costume. A deep mixture of Payne's grey and violet, lightened above the folds with white, is warmed when dry with a thin wash of yellow ochre laid over it.

4 DESCRIBING THE HAIR

Try to see the hair not as individual strands but as a soft tonal mass of light and dark brushstrokes. Add pigment hues of burnt umber and burnt sienna with a fine sable brush using the wet-in-wet technique.

Simple brush marks make the most convincing hair, which should be softened with a dry brush.

Model the basic features of cheek, jawline, eyeline and nose on the wet canvas surface with a fine sable brush.

6 DEFINING THE BABY AND CRADLE

Using the same hues as for step 5, describe the infant with warm flesh tones and a little grey for the hairline. Also, strengthen the hints of pink in the draped ribbon, and slightly darken the lace at the front of the cradle.

PAINTING THE FACE AND HANDS 5

Morisot tended to use the paint thicker and wetter for skin tones. Mix up these tones using cadmium red, flesh tint, yellow ochre and white.

DETAILING THE BACKGROUND (7)

The curtains are an important framing device for the figure, and because this study has little spatial depth, some detail is necessary. Define them with thin strokes of yellow ochre, white and Payne's grey, building up gauzy layers of paint.

The soft look of the curtains is obtained through smooth blending with the finger.

(8) **FINAL TOUCHES**

Fine brushwork where it matters will bring *The Cradle* to a suitable conclusion. Pay attention to the choker around the neck and lace trimmings about the dress that can be wispily touched in with a No. 4 sable brush. Draw a few strands of hair out from the head using burnt umber and white, and decide whether to add small flecked highlights, perhaps to the sleeve, chair back or lace, using white.

THE MAGIC APPLE TREE

Samuel Palmer

SAMUEL PALMER *1805–1881*

Before you begin . . .

The rich luminosity and heavily layered dappling of brush marks are defining features of Palmer's work. They are achievable with sensitivity and care made possible by close study of the original. To create the solidity of the detailed forms, India ink is used with strong mixes of watercolour, for which a porcelain palette is recommended. The watercolour sheet should be wetted and stretched onto a board using gummed tape and drawn into when dry. Have a spare piece of watercolour paper handy to practise techniques, as well as a scrap of paper to lean on. A small selection of round sable brushes is ample. You will also need a dip pen with suitable drawing nib (mapping pen) for the outlining.

Materials needed

1 Basic supplies (page 10)
2 Black India ink
3 Rough-textured watercolour sheet (25 x 31 cm/ 10 in x 12 in)
4 Paper (to lean on)
5 Spare watercolour paper
6 Watercolours/gouache
7 Brushes: sable rounds (Nos. 2–6)
8 Drawing pen and nib
9 Porcelain palette
10 Red chalk paper

THE PALETTE

Opulent colours, not necessarily associated with the medium of watercolour, can be used with great effect to create mystical pictures.

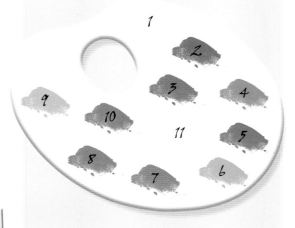

1	Chrome yellow	7	Sepia
2	Vermilion	8	Carmine
3	Burnt sienna	9	Yellow ochre
4	Ultramarine	10	Crimson
5	Prussian blue	11	White gouache
6	Viridian green		

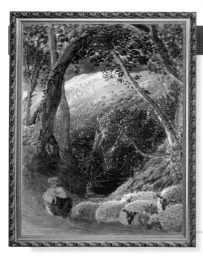

About this painting

☛ The mystical leaning of Samuel Palmer's imagination was intensified when he met the great visionary, William Blake, in 1824. Inspired, he moved from London to the village of Shoreham, Kent, and in water meadows and woodland, discovered a paradise in harmony with nature, abundant with harvest, and ripe and ready to record. The Magic Apple Tree, 1830, is the hub of a small collection of richly painted watercolours. The hills drip with golden cornfields above which hangs a heavy grey sky. From steep banks rises an arch of trees framing a smaller apple tree laden with glowing red fruit — the central theme of the piece. The church spire rises out of the valley shadow, and in the foreground sits a musing shepherd, tending his flock. The dappled technique and intense colour are unique to the artist.

1 TRACING THE PAINTING

Prepare the template using the grid on page 159. Transfer the outlines of the composition onto a heavily textured rough sheet of watercolour paper using your red chalk paper.

2 OUTLINING IN INK

Loosely sketch over the outlines with black India ink. The technique relies on the line thinning as the ink from the pen reservoir is used up.

This does not need to be too detailed. The main shapes and their position on the paper are what is important.

Be sensitive when handling the pen and ink lines. Mimic the original.

Painter's Pointer

Like Palmer, be fluid in your thinking. The success of the final piece will be determined by the overlap of light, sketchy pen lines and layering of fluid washes.

To avoid hard edges, wet-in-wet technique is the best way to blend these colours.

LAYING BACKGROUND WASHES 3

With your largest sable brush, wash the cornfields with chrome yellow at the top, seeping into vermilion and burnt sienna at the bottom, where the field meets the treetops.

4 PAINTING THE SKY

The brooding sky is a combination of ultramarine and Prussian blue dropped onto the paper as heavy stains.

5 ESTABLISHING FOREGROUND TONES

Broadly spread washes of burnt sienna and chrome yellow across the lower foreground (leaving the shepherd and sheep as white, bare paper). Paint the trunks and branches of the trees with burnt sienna.

Add strokes of viridian green onto the sky when dry, as a base for the foliage.

Follow the direction of the leaves with your loaded brush.

6 REFINING THE SCENE

Sketchily draw in the details of the foliage — small leaf 'ovals' will work — and colour them with dabs of viridian green and Prussian blue using your No. 2 round sable brush.

Retain the highlights on the backs of the sheep by leaving the paper bare. These portray the light and mood of the scene.

FURTHER TONAL LAYERS 7

Build up extra layers of sepia and burnt sienna into the bank below the tree using short strokes of a No. 4 brush. In the foreground the lap and legs of the shepherd should also be tinted with sepia, as should the fleeces, but very lightly.

8 FINE DETAILS

To enrich the apple tree and middle-distance foliage, paint with a redder choice of colours – vermilion, burnt sienna and carmine. Selected detail should be described in the cornfield using the dip pen and India ink and further washes of yellow ochre, crimson and chrome yellow blended into this.

The smallest of marks made in the field give the viewer clues as to its nature.

UNIFYING THE TONES 9

The rest of the composition may need final adjustment. Look carefully and decide whether the sheep require further darkening to describe their roundness. Add any highlights to the cornfield, trees and their foliage using white gouache (body) paint.

RED ROOFS

CAMILLE PISSARRO 1830–1903

Before you begin . . .

'Do not define too closely the outlines of things, it is the brushstroke of the right value and colour that should produce the drawing,' the artist once advised the young painter, Louis Le Bail, in an informal note. This comment gives real insight into the type of attitude to be adopted for this canvas. You will need to take an overview of the whole scene and work at placing tones of the correct colour and value everywhere. A broad range of round and flat-bristle brushes is an essential vehicle for laying the hues onto canvas to re-create the appearance of it having been painted *en plein air*. The key to this painting's success is its red roofs that glow through the separating screen of bare trees.

Materials needed

1 Basic supplies (page 10)
2 Medium-texture (284-g/10-oz) duck cotton canvas (53 cm x 66 cm/ 21 in x 26 in)
3 Acrylic paints
4 Brushes: bristle rounds (Nos. 2, 4, 6)/bristle flats (Nos. 6, 8, 10)
5 Red chalk paper

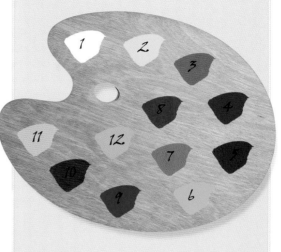

THE PALETTE

Melodic colours are lyrically composed in the painting to throw the bouncing light in every direction around the canvas.

1	White	7	Cadmium orange
2	Cadmium yellow	8	Cadmium red
3	Burnt sienna	9	Prussian blue
4	Ultramarine	10	Payne's grey
5	Violet	11	Flesh tint
6	Sap green	12	Yellow ochre

About this painting

☞ *A leading elder of Impressionism when this painting was made, Pissarro had settled at Pointoise, France, where he followed earlier advice to paint directly out of doors, falling in and out of pure Impressionism as the whim took him.* Red Roofs, *1877, is an intense canvas of reds, mingling and harmonising in subtle tonal nuances. All is blurred yet clear simultaneously, as the viewer's eye travels through the layers of painterly brilliance, only separating foreground trees from middle-ground buildings and background slopes at a distance. There is a strange dualism present in this study between the vibrant movement of paint marks and the stillness of the elements in the composition. The resulting effect cleverly transports our senses into the heart of a place we feel we know very well.*

① PREPARING THE CANVAS

Prepare the template using the grid on page 160. Lay a cream wash using white and a little cadmium yellow to 'heat' the blank expanse gently. Transfer the template sketch to the canvas with red chalk paper, and darken the traced lines with burnt sienna and a small flat brush. Even at such an early stage, block the roof shapes in with broad, flat brushwork. These shapes will act as a good starting point for successive layers and tones.

Keep the outlines really simple, remembering paint will eventually obliterate them.

The three colours blend optically into a warm pale blue.

ESTABLISHING THE SKY ②

Cover the top band of the composition with assorted impasto flecks of ultramarine, violet and white using a medium round bristle brush in a strongly horizontal direction.

With white in the mix there is a dazzling light.

③ CREATING THE BACKGROUND

Lively vertical dabs of sap green establish the background fields, which are warmed up under the hot sun with cadmium yellow, cadmium orange and burnt sienna. The unification of these vibrant tones is achieved with the addition of broken dashes of white.

4 LAYING THE FLOOR

The bottom strip of the painting becomes a curving floor through which the trees twist towards the sky. Use colours as for step 3.

The uncluttered space in the foreground is essential as a lead into the central activity.

DETAILING THE ROOFS 5

The roofs – the only flat passages of colour – are pitched using the earthy base of cadmium red, orange and burnt sienna, with the capping and chimneys glaring intensely in white. The shadows created by the chimneys are brushed in Prussian blue, violet and a little Payne's grey. Tiles are suggested as short horizontal strokes.

Definition of the roof structures is important at this stage before it is blended with fractured colour.

6 DESCRIBING THE SOLIDITY OF BUILDINGS

At this relatively simple stage, surface the walls of the houses in white, flesh tint and a hint of ultramarine.

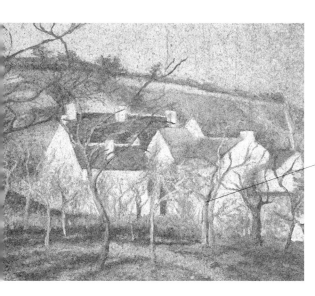

7 ADDING FOREGROUND TREES

The addition of trees assists with formalising the illusion of depth, being superimposed on the broader mass of buildings. Sap green, yellow ochre and burnt sienna should be used.

The influence of Japanese prints on Pissarro is evident in the way that the trees divide the composition with their angular ascent of the painting.

FINISHING TOUCHES 8

The second row of trees lining up behind the houses is more subtly integrated with cadmium red, yellow ochre and burnt sienna. The tops are deliberately cropped out of the frame to give the illusion of height, thereby accentuating the steepness of the slope behind.

Flecks of yellow in the fields and hedgerows help to lift the weight of colour. The trees draw further attention with firmer Payne's-grey outlines.

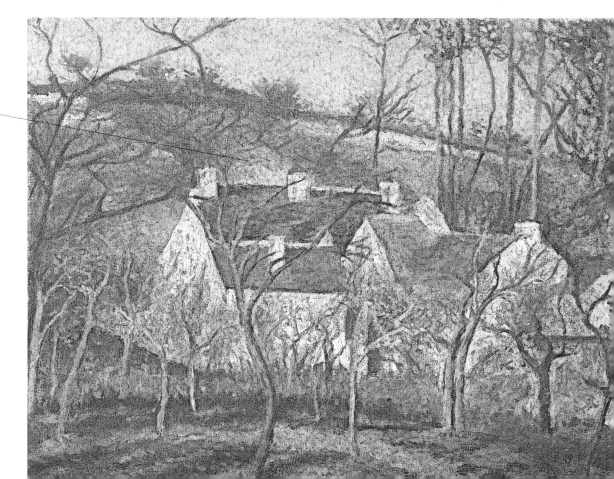

FLEURS

od. Redon

ODILON REDON *1840–1916*

Before you begin . . .

Odilon Redon's highly personal use of colour and passage of mark gives them a unique quality. How the stroke is applied is as important to the meaning of the picture as the actual form being described. Before you begin, practise mark-making on a testing sheet with flat-bristle brushes and finer sable rounds. Use a dry brush with very little added water to achieve his layers of dusty-looking pastel colour. A smooth-textured canvas of 53 cm x 66 cm (21 in x 26 in) is the actual size of the original piece

and will allow you to exploit a broad visual vocabulary without restriction. A selection of bristle brushes will provide your main strokes, but for soft blending a fine sable or synthetic brush is required.

Materials needed

1 Basic supplies (page 10)
2 Medium-smooth texture (341-g/12-oz) duck cotton canvas (53 cm x 66 cm/21 in x 26 in)
3 Testing sheet
4 Acrylic paints
5 Brushes: bristle flats (Nos. 4, 6, 8)/sable rounds (Nos. 4, 6)
6 Red chalk paper

THE PALETTE

A strong palette of pure pigments and an unusually high content of black are what give this painting its uniquely recognisable style.

1	Yellow ochre	*7*	Cadmium red
2	Raw sienna	*8*	Cerulean blue
3	Sap green	*9*	Cobalt blue
4	Cadmium yellow	*10*	Violet
5	Black	*11*	Payne's grey
6	Cadmium orange	*12*	Pink

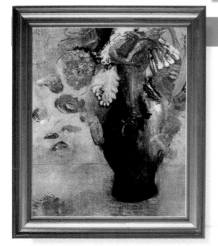

About this painting

Caught up in the dreamy world of symbolism, a literary movement among French poets, Odilon Redon took pleasure in the visualisation of fantastic, personal dreams. Aside from the musing angels staring into opulent blue skies, or voyagers in boats, he also delighted in the simplicity of flower studies. Showering the surface, they break out into the evocative imagery of underwater shells, plants and even a carpet of stars. Such 'flowering stroke' motifs, as they were termed, are evident in Fleurs*, painted in 1903. Details of place and setting are nonexistent, and still-life elements in blues, reds and yellows suggest objects cascading into actual space. The hint of the mantle, a mere line barely describing a believable setting, is in marked contrast to the imposing ceramic vase with figure.*

② LAYING THE BACKGROUND

Scumble sap green, cadmium yellow and yellow ochre onto the background with a dry brush, mixing your hues directly onto the canvas.

The shadow areas help to emphasise the shape of the vase.

① PREPARING THE CANVAS

Prepare the template using the grid on page 161. Trace onto your canvas the basic outlines of the flowers and vase using red chalk paper. Prepare a light wash of yellow ochre and brush it over the whole surface of the canvas. Next, strengthen the outlines with raw sienna.

Keep the outline strong so that it does not get lost when the paint is washed on.

When tinting, the paint consistency needs to be thinner and applied fairly loosely around the flower outlines.

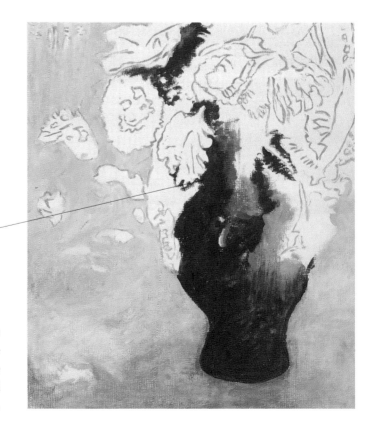

TINTING THE VASE ③

Mix black and sap green onto your palette and then apply it with a large brush to the solid area of the vase and in between selected areas of foliage.

The blue tones provide the illusion of depth in the leafy layers of the display.

PAINTING THE FLOWERS 4

As the flowers are all described in warm colours, use cadmium orange, cadmium red and cadmium yellow to stipple the tones found in the petal shapes; use black and sap green for the stamens.

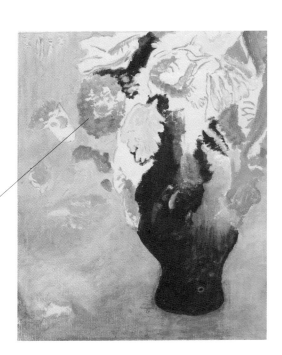

Vitality is captured in the warmth and intensity of the red and orange hues.

5 **ADDING COLOUR COMPLEMENTS**

To create a more startling and seductive picture, introduce cerulean and cobalt blue to the flower arrangement on the stems, the undersides and the heads.

Painter's Pointer

Enjoy the freedom of brushing looser marks in the dreamy spirit of Redon. The mix of dry and wetter pigment creates the believable impression of the flower spray.

FURTHER SOFTENING 6

Blend the greenish-grey leaf shapes into the background under the sensitive control of your index finger with sap green, Payne's grey and yellow ochre.

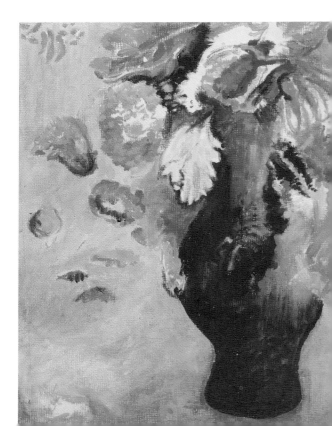

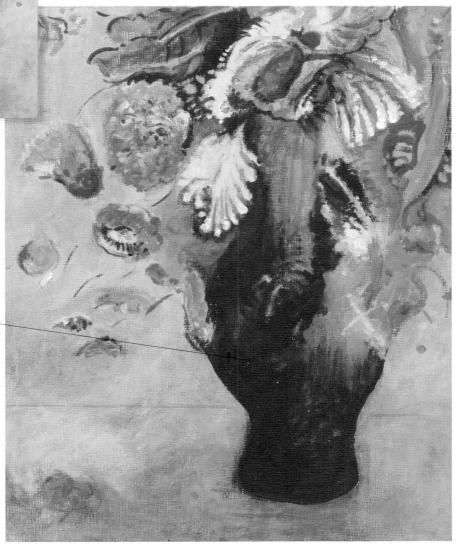

7 HIGHLIGHTING THE PICTURE

Take a small brush and lightly dab violet, pink and cream (cadmium yellow and white) highlights onto the petals where they catch the light.

Highlights give extra sparkle to an already lively composition. For full effect, use sparingly.

The heavy staining on the vase contrasts powerfully with the brighter, broken colour of the blooms. This imbalance assists the mystery of this delightful study.

FINAL TOUCHES 8

Redefine the main structures of the painting – the stalks and edges of the petals – with finer strokes of black.

BOATING ON THE SEINE

Renoir

PIERRE-AUGUSTE RENOIR *1841–1919*

Before you begin . . .

Impressionism works best when the detail breaks down into a haze of pure dazzling colour. Acrylic is a fast-drying medium suited to layering glazes and impasto marks, but unlike oil, it is easy to get into the habit of picking up other colours without washing out the brush thoroughly from the previous use. Retain the sparkle in your hues with regular brush cleaning. To achieve similar results to Renoir, you will need to apply short, dry paint strokes in thin coats and build up a dense layer. A bright flat-bristle brush is best for this, having much shorter hairs than other flats. The canvas should have a fairly fine weave and be white-primed with an acrylic primer or emulsion.

Materials needed

1 Basic supplies (page 10)
2 Medium-smooth texture (341-g/ 12-oz) duck cotton canvas (41 cm x 61 cm/16 in x 24 in)
3 Acrylic primer/ white emulsion
4 Acrylic paints
5 Brushes: bristle bright flats (Nos. 4, 6, 8, 10)
6 Red chalk paper

THE PALETTE

Work straight from the tube and mix the colours with a fairly dry brush directly on the canvas.

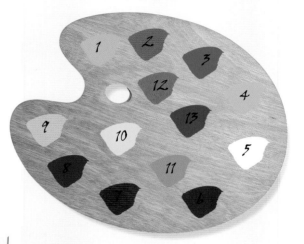

1	Yellow ochre	8	Ultramarine
2	Burnt sienna	9	Flesh tint
3	Cobalt blue	10	Cadmium yellow
4	Sap green	11	Raw sienna
5	White	12	Crimson
6	Violet	13	Lilac
7	Payne's grey		

About this painting

🖎 *A skilful innovator of the spectral palette, Renoir had a gift for interpreting landscapes, portraits and ordinary scenes in life with a sincere feeling for beauty, light and sparkling colours. By 1870, he had become a leading Impressionist, choosing mainly to study figures in modern social settings. This scene at Asnières on the Seine in 1878 is, unusually for Renoir, a pure piece of Impressionism — luminosity played on the surfaces of land and water as colour. On a sunny day, two women drift lazily in a skiff. The vivid orange of the boat complements the blue of the river, and dabs of both hues mix optically in the reflections. The peace of the scene is interrupted by the approaching train in the distance, showing the artist's acceptance of advancing industrialisation.*

① OUTLINING THE CANVAS

Prepare the template using the grid on page 162. Lay a very light wash of yellow ochre across the canvas. When dry, trace the outline onto the canvas using red chalk paper and go over it with a small sable brush and burnt sienna.

This outline merely acts as a loose guide on an Impressionistic painting.

② PAINTING THE RIVER

Take a wide flat-bristle brush and broadly execute a cobalt blue wash interspersed with short horizontal strokes of cobalt blue and, where light is reflecting on the water's surface, white.

These strokes give the impression of ripples on the surface reflecting the sunny day.

Large amassed objects can be rapidly painted with Impressionistic techniques. Scumble the bank of trees just above the horizon line using sap green and white.

BLOCKING IN THE FOLIAGE ③

Renoir's plant forms have a particular style, softly blended with plenty of movement. Deftly scrub the soft sap-green marks of foliage into the bottom left-hand corner of the picture, and blend in white and yellow ochre while it is still wet.

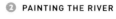

DEPICTING THE BACKGROUND ④

Renoir used the theory of aerial perspective, employing paler, cooler hues for their recessive visual qualities. Cobalt blue is added into the background sky, railway embankment and house.

Flesh tint is a not-too-startling choice for the light-reflecting surfaces, such as water ripples.

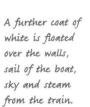

A further coat of white is floated over the walls, sail of the boat, sky and steam from the train.

The simplest sweeps of colour and stroke can express so much about the boating ladies.

⑤ **ADDING RIVER DETAILS**

Take a small round bristle brush and work it delicately into the shadow areas with ultramarine, Payne's grey and violet.

DETAILING THE BOAT AND FIGURES ⑥

The skiff boat is worked in cadmium yellow, raw sienna and a tiny amount of burnt sienna. Address the figures with crimson and white with lilac, and cobalt blue and white.

7 REFINING THE BACKGROUND

Detail should be added at this penultimate
stage to the background, using a small brush
to mix dry pigment directly onto the canvas.

FINISHING TOUCHES 8

Still using the fine brush, define the leaf shapes
on the foreground bank with thin, directional
strokes of sap green, white and cadmium yellow.
Further enhance the contrast of ripples against
the deeper blue stillness beneath by adding
in ultramarine and Payne's-grey marks.

*Darkening the areas
under the bridge and
in the foreground helps
to separate the land
shapes from the glassy
surfaces of the water.*

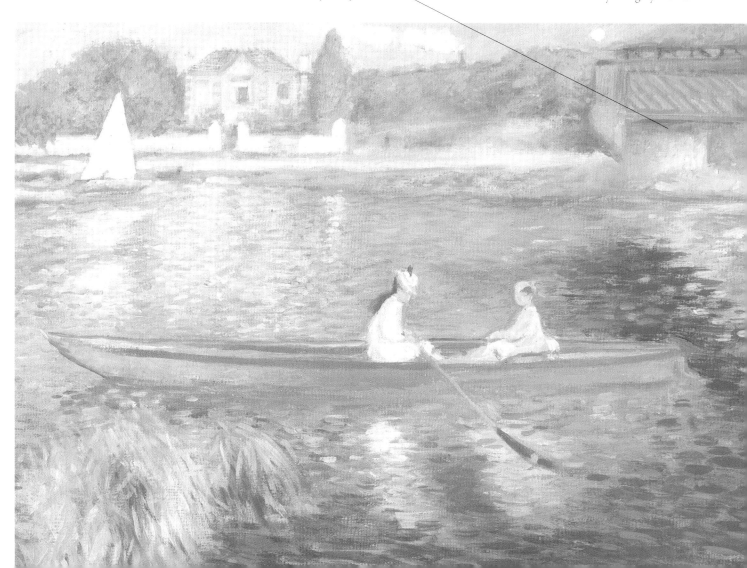

THE SWING

PIERRE-AUGUSTE RENOIR *1841–1919*

Before you begin . . .

The Swing is a cheery painting, which abounds in richly textured glazes and impasto, and displays a wide repertoire of brush marks and strokes. The full and soft swirling movement of the brush is in direct contrast to the stationary, pre-active pose of the lady and her companions. Match the range of marks with a similar range of mark-makers. Use bright flat-bristle brushes because the shorter hair length will be best achieved using short dabbed marks. The more flowing strokes will be better applied using round bristle brushes. Renoir used preprimed canvases to work on – you can either do the same or prime a canvas with a ready-formulated acrylic primer or white emulsion.

Materials needed

1 Basic supplies
 (page 10)
2 Medium texture
 (284-g/10-oz)
 primed duck
 cotton canvas
 (41 cm x 61 cm/
 16 in x 24 in)
3 2B pencil

4 Acrylic primer/white
 emulsion (if canvas
 not preprimed)
5 Acrylic paints
6 Brushes: bright
 bristle flats (Nos. 6,
 8, 10)/bristle
 rounds (Nos. 2, 4, 6)
7 Red chalk paper

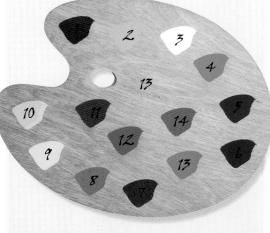

THE PALETTE

The palette contains a predominance of blue and violet complemented by a warmish tinge of creamy orange.

1	Payne's grey	8	Crimson
2	Yellow ochre	9	Cadmium yellow
3	White	10	Flesh tint
4	Cerulean blue	11	Burnt umber
5	Ultramarine	12	Phthalo green
6	Violet	13	Emerald green
7	Cadmium red	14	Burnt sienna

About this painting

☛ *Where Monet had gloried in the changing landscape, Renoir delighted in the human situation, often set within a landscape context. Friends and lovers were subjects, and he fondly composed them against a backdrop of effective light and colour for the sensual pleasures of his audience. The Swing, 1876, is a spring study made in the Parisian garden of 12 Rue Corot. Lyrical and intimate, the young actress Jeanne stands on the swing, aside of her male companions and a child, but does not engage them, preferring instead to look askance. Her expression is caught by the sunlight filtering through dappled leaf shade, which creates splashes of colour and purple shadows. Renoir's interest in light and the juxtaposition of large areas of complementary colour led him to create larger, broader painted canvases, celebrating* joie de vivre.

① TRACING ONTO THE CANVAS

Prepare the template using the grid on page 163. Use your red chalk paper and a fairly sharp pencil to imprint your outline drawing onto the white primed canvas.

The scumbles are a huge help because they differentiate the figures, the key elements of the painting, from the background.

Check that your tracing is accurate, paying particular attention to the figures.

Impressionism is concerned with converting specific forms into broader masses of colour. The leaf shapes are implied by the strokes of the brush.

③ DEEPENING THE BACKGROUND SHADOWS

With cerulean blue, ultramarine and a tinge of white, darken down the shadowy masses of the background foliage.

SCUMBLING THE BACKGROUND ②

Separate the figures from the background using thin scumbles of Payne's grey, yellow ochre and white. Apply these with broad, scribbling gestures from a large flat brush.

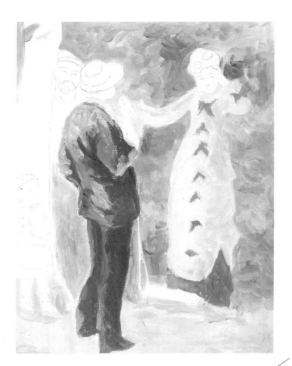

4 ESTABLISHING THE CENTRAL FIGURES

The clothing of the man is a very dark tone. In contrast, the woman's clothing is very white. His jacket and pants are delicately touched with violet, ultramarine and cadmium red – much lighter on the back from where light emanates. White, Payne's grey, crimson and cadmium yellow establish the dress.

Shadow colours are violet-based, the highlights yellow-based.

The dappled ground shadows give a significant clue about the path of the light. Paint them in with Payne's grey and cerulean blue and further deepen the foliage.

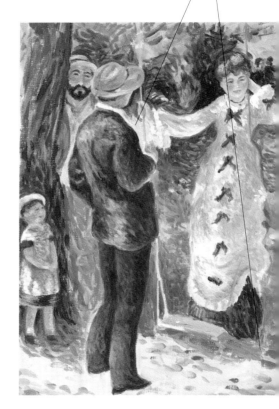

5 ADDING FURTHER DETAILS

Apply flesh tint and cadmium red as flat tone on the faces and hands. Paint hair and hats in burnt umber, cadmium yellow, Payne's grey and white. The child, tree and man on the left with the beard should be lightly scumbled using the same. With more accuracy, delineate the rope and swing seat in cadmium red, flesh tint and white, employing a small round brush.

DEVELOPING THE CHARACTERS 6

The clothes, faces and hands are developed in small dabbing brushstrokes with your small bright brush, using the current palette.

7 REFINING THE BACKGROUND

Dappled shade is abundant. Work in the foliage in a much heavier way with cerulean blue, phthalo green, emerald green and yellow ochre. The ground complements it with a warm red tint of cadmium red and yellow ochre.

White highlights are strategically placed down the centre of the woman's dress, where dark blue bows abound.

FINISHING TOUCHES 8

The final layer of paint to be applied is the adjustment of tones and hues in the trees of the background and foreground. Use burnt sienna for the trunks, with green where foliage meets bark. The shadows are warmed with violet and cadmium red.

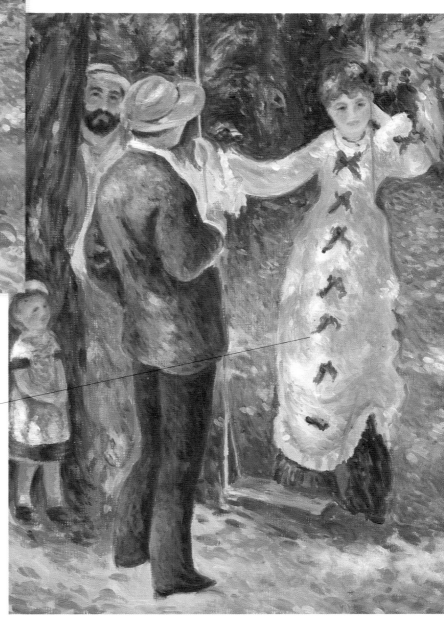

WOMAN WITH BENT KNEE

EGON SCHIELE *1890–1918*

Before you begin . . .

Immaculate, nervous draughtsmanship and an abraded palette of unrefined colours mark Egon Schiele above his contemporaries. To draw like Schiele, you will need to adjust the pencil pressure, alter the grip and follow the traced line in an agitated way. Control is not compromised, and care must still be taken in the areas of detail, such as the delicate facial features. Understatement is key in Schiele's work – what you leave out is as important as what you put in – and surfaces have textures revealed where the light of the prepared paper shines beneath the brushy layer of paint. It is best to use a slightly textured paper in cream, or one that is smoothly washed over with a wash of yellow ochre and white.

Materials needed

1 *Basic supplies (page 10)*
2 *Slightly textured cream 300-gsm cartridge paper (46 cm x 31 cm/ 18 in x 12 in)*
3 *Gouache tubes*
4 *Brushes: sable flats (Nos. 6, 8, 10)/sable rounds (Nos. 2, 4, 6)*
5 *Brown colouring pencil*
6 *Black crayon*
7 *2B graphite pencil*

THE PALETTE

Deep, bold gouache colours in a creamy 'from-the-tube' consistency will dictate the mood of this portrait study.

1	Cadmium red	*5*	Black
2	Yellow ochre	*6*	Emerald green
3	White	*7*	Ultramarine
4	Burnt sienna		

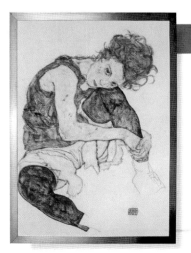

About this painting

☞ *Austrian Expressionist Egon Schiele shot to the attention of the Viennese public with his sexually charged images. He applied the influence of Freudian psychology to his portraits – the emaciated torsos of semi-clad figures stare anxiously out from starkly empty canvases. In 1917, when* Woman with Bent Knee *was made, Schiele was enjoying extensive recognition for his work with a comfortable living to match, which might explain the softer approach to the sitter. She still strikes a familiar erotic pose that is slightly awkward and uncompromising, but somehow it is not as threatening as previous female works. However, the bodily contortions within the compact compositional space still put the viewer on edge, and the scratchy opaque green and dark brown hues offer little comfort in the overall ambience of the painting.*

① TRACING THE OUTLINE

Trace the outline of the composition onto the cream paper from the template on page 164 with a 2B pencil. With this particular image, accuracy is of the utmost importance, so take your time to make your copy as near to the original as possible.

It is essential that you trace accurately and cleanly onto your paper because mistakes will be harder to correct later on.

If the pencil is too sharp, it will not produce the thick line necessary for the first layer of the painting.

The dryness of the stipple marks allows plenty of cream to show through.

STRENGTHENING ② THE OUTLINE

Follow the outline with a relatively sharp brown colouring pencil. By altering the pressure of the pencil, you can bring the line to life as it progresses over the fluctuating body curves.

TINTING THE FLESH ③

A medium flat brush is required to apply the flesh tones. It must be very dry, and the paint should not be watered down, so that you can stipple the marks onto the surface. To make Schiele's flesh hue, blend cadmium red, yellow ochre and plenty of white gouache with your finger.

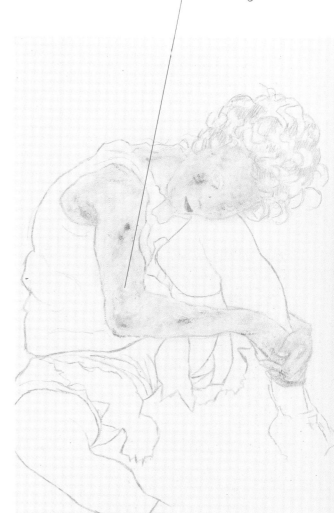

PAINTING THE LEGS ❹

Scumbles of burnt sienna and black worked with a dry brush in loose, circular movements are built up to produce the leg forms.

Darken shadows in the folds with ultramarine, too.

ADDING THE MAJOR COLOUR ❺

The green tank top constitutes the major colour surface in this composition. To match the mood of the overall picture, mix a harder, steely green by adding a third part of ultramarine to the emerald green. Work it with a medium flat-bristle brush as you did the stockings, all the time considering the solidity and form of the body.

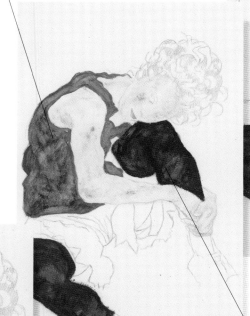

When painting the legs, scumble to describe the form as though you were actually painting around the form.

Any lighter patches showing through are useful in describing how the light falls on the curved surfaces of the body.

Where the wet paint and wax do not mix, they will naturally repel each other, creating a broken texture.

❻ CONTRASTING DARKS WITH LIGHTS

Darken the folds of the bloomers in selected places using the waxy line of a black crayon, and dab the surface with white, allowing the line to dissolve slightly before smudging it into the background.

Study your picture to make sure that all the stages of painting are working well together. Make adjustments of mark and colour wherever necessary.

❼ DESCRIBING THE HAIR

To give the hair its bounce, lightly swirl a base of cadmium red and burnt sienna over the scalp using a medium flat-bristle brush, keeping all strokes fluid. On top of this, scumble a little dry black paint around the curls to unify the tones.

Be careful not to overdo the strokes of the hair. Give extra description to the occasional lock with the flourish of a fine sable brush.

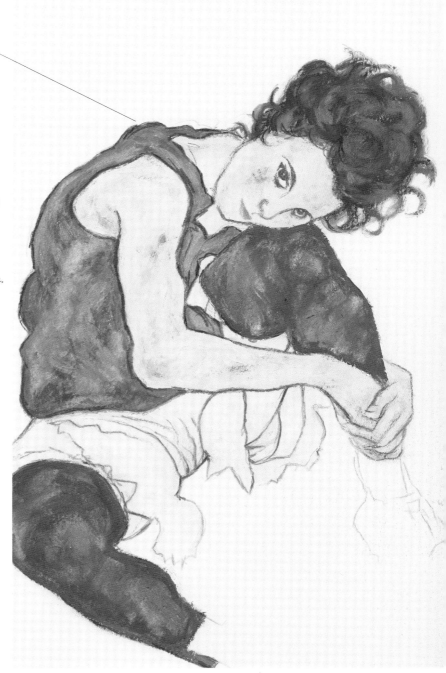

FINISHING TOUCHES ❽

Add facial features, re-outline clothing and define the fingers with a sensitive handling of the black crayon. Lighten the stockings and top by removing pigment with a dampened sable brush. Adjust skin tones by adding scumbles of yellow ochre.

THE CIRCUS

Seurat

GEORGES SEURAT *1859–1891*

Before you begin . . .

The thrills of the circus, as captured by Georges Seurat, rely on a graphic poster, snapshot style, using fine-dot stippling. You will need to equip yourself with a range of fine bristle brushes in order to implement the keenly observed details of the show as it occurs. Underpinning the animated surface are broader layers of diluted pure colours, which require the broader sweep of flat-bristle or hog-hair brushes in larger sizes. To undertake this painting, you will need a finely woven stretched and white-primed canvas of about 41 cm x 61 cm (16 in x 24 in), onto which you will push down the tracing using B and 2H pencils and a palette of vivid acrylic paints.

Materials needed

1 Basic supplies (page 10)
2 Medium-smooth texture (341-g/ 12-oz) duck cotton canvas (41 cm x 61 cm/16 in x 24 in)
3 Acrylic paints
4 Brushes: bristle flats (Nos. 2, 4, 6, 8)
5 Tracing paper
6 B and 2H pencils

THE PALETTE

With the exception of flesh tint, all the colours in Seurat's palette work as complementary pairs around the colour wheel. White is made up of the spectral colours.

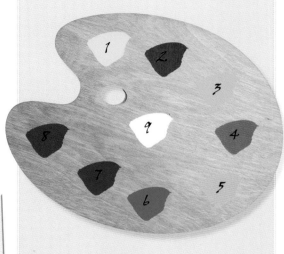

1 Cadmium yellow 6 Cobalt blue
2 Cadmium red 7 Ultramarine
3 Yellow ochre 8 Violet
4 Burnt sienna 9 White
5 Flesh tint

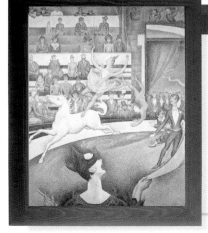

About this painting

 Georges Seurat broke out of the classical mould in pursuit of rendition through colour. His hunger led him to develop his own style, known as 'divisionism' or Pointillism, which was rooted in the belief that art should be based on structured systems. The intensely coloured dots laid next to each other blend together before the viewer's eye, imitating more effectively than Impressionism, the resonant effects of light falling onto objects in a scene. The Circus shows clearly how Seurat, unlike his plein air predecessors, was heavily influenced by the geometrical construction of the Renaissance masters and native neoclassicist, Ingres. This is echoed through its controlled composition of spirals, ellipses and circles, with the rectangular entrance to the left providing the only break from the helical movement.

❶ ESTABLISHING THE OUTLINE

Prepare the template using the grid
on page 165. Trace an accurate
outline of the picture onto a primed
white canvas. Do this by gently
shading the graphite of the B pencil
over the back of the tracing, and then
transfer it crisply to the canvas
with the pencil point.

There is no added
white in this
painting. The primed
canvas showing
through provides
the white areas.

Painter's Pointer

Layering of pure colour is the key to
a successful Seurat. Keep washes
thin and brushes clean to ensure
that the stippled top coat dazzles
above the translucent base.

BLOCKING IN BASE COLOURS ❷

The purity and lightness of colour in
the picture owes much to the strong
build-up of cadmium-yellow tints in
the underpainting. Make sure they are
laid as thin washes so as not
to obscure the outlines.

❸ ADDING DEPTH AND SHADOW TONES

By simply brushing in the hat and shirt of the clown, the doorway and ringside seating with thin washes of cadmium red, the composition will gain extraordinary spatial depth. When the washes have fully dried, paint yellow ochre with a dry brush into the shadow areas of the ring, seating and curtains by stippling with a small hog-hair or bristle brush.

❹ ENRICHING COLOUR

Burnt sienna is added to the shadows and clothing, and flesh tint is added to the body and face of the ballerina, ringmaster and audience. Such simple applications of hue inject life into a static scene.

Blending passages of burnt sienna with a dry brush around the main foreground figure, the clown, pushes him to the fore of the picture.

These hues can also be used to deepen the folds of the turban.

The horizontal bands of red help to divide the picture into three planes: the foreground performing clown, the middleground acrobat and rider, and the background audience.

FURTHER DEPTH ❺

The overall strength of *The Circus* is bolstered by the addition of the cooler range of spectral colours into the shadow areas. Cobalt blue, ultramarine and violet should all be applied as small dabs with a small hog-hair or bristle brush.

6 FINER DETAIL

Work on the bodily form of the horse, the neck of the clown and pale shadows against the ringside and seating with a blend of white and ultramarine.

Strengthen the reds in the hat with the stippled dots of violet for a greater illusion of three dimensions.

Using appropriate colours, carefully stipple all of the composition to unify the whole.

UNIFYING THE COMPOSITION 7

Further dry-brush stippling with red and blue tones creates greater contrast between the light and dark areas in the painting, resulting in greater impact.

SNOW AT LOUVECIENNES

ALFRED SISLEY *1839–1899*

Before you begin . . .

It's sometimes tempting to think that stroking a canvas with paint squeezed directly from the tube is all that is required to re-create an Impressionist painting. But to achieve the subtlety of both mark and palette found in Sisley's work requires intense concentration and sensitivity in handling the media. Before you even begin to prepare your impasto pigments, the smooth canvas should be lightly scumbled with a diluted, mixed wash of Payne's grey and ultramarine. A selection of flat-bristle brushes will provide your key strokes, but have a small round sable brush at the ready for the soft blending of the snow and the descriptions of house windows and fence posts.

Materials needed

1 Basic supplies
 (page 10)
2 Smooth-texture
 (426-g/15-oz)
 duck cotton canvas
 (46 cm x 46 cm/
 18 in x 18 in)
3 Acrylic paints
4 Brushes: bristle
 flats (Nos. 4, 6,
 8)/small sable
 round (No. 2)
5 Knife
6 Red chalk paper

THE PALETTE

Have plenty of white on hand and discover how many colours are needed to make up the white of the snow by following the scientific methods of the Impressionists.

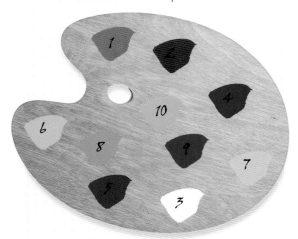

1	Burnt sienna	*6*	Yellow ochre
2	Payne's grey	*7*	Flesh tint
3	White	*8*	Raw sienna
4	Ultramarine	*9*	Prussian blue
5	Violet	*10*	Sap green

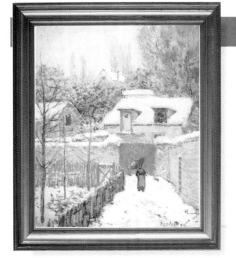

About this painting

☞ *Alfred Sisley was the Impressionists' poet of the seasons. His early work showed the influence of Corot in its sombre tonal expression, but after meeting Monet and Renoir, his palette lightened and his brushstrokes became much freer. Exclusively working as a landscape artist, he had a rare talent for the subtle evocation of atmosphere so convincingly displayed in* Snow at Louveciennes, *one of a sequence of snowy paintings in which he relished responding to the pearly effect of light reflecting on fresh snow and to its soft, impasto texture. The square 'window' of the canvas draws us onto the path of the rural village and into the footsteps of the woman with an umbrella. Its overall pinky cast with blurring hints of violet in the background trees give this masterpiece its endearing qualities.*

① SKETCHING THE OUTLINES

Prepare the template using the grid on page 166 and transfer the drawing onto the canvas using the red chalk paper. Go over the outlines in burnt sienna with a round brush to demark the image clearly, then block in the doors, windows and fences. Add in the sky area using Payne's grey and a smidgen of yellow ochre.

Use the burnt sienna with a fairly dry brush.

② BLOCKING IN THE SNOW

Using white acrylic, block in the larger areas of snow with short, decisive directional strokes using a medium-sized flat brush.

Dry impasto flecks of white give the impression of snow-laden boughs.

Allow some areas of underpainting to show through the snow and to create the illusion of depth.

> ## Painter's Pointer
> *You may initially prefer to transfer the thick paint from the palette to the canvas with a painting knife.*

PAINTING THE MIDDLE GROUND ③

Work up the foliage, trees and sky with a creamy palette of ultramarine, Payne's grey and violet. Across the sky drag a very light tint of yellow ochre laced with white to add warmth to the picture and capture the snowy air.

RENDERING THE BUILDINGS ④

Not every brick needs to be painted to achieve realism. Pick out the odd brick in the houses and garden walls with a dash of white, flesh tint and yellow ochre on the paler surfaces, and burnt sienna and Payne's grey on the darker.

A small flat-bristle brush (preferably a 'bright') will naturally form a brick mark on the paint surface.

⑤ **ADDING FINER DETAILS**

Draw out the timbered fence with yellow ochre, burnt sienna, Payne's grey and raw sienna. For woodwork on the windows and the gate, use yellow ochre, burnt sienna and a hint of white.

Allow the brush marks to be less rigid or more broken with an Impressionist style.

The trees add vertical linear balance to a very horizontally balanced picture and should be boldly painted in.

DESCRIBING THE FOLIAGE ⑥

Form leaf masses with a medium flat brush using Payne's grey and Prussian blue to denote basic shapes. The branches of the foreground trees are drawn with a round sable or flat-bristle-brush combination in Payne's grey and raw sienna.

7 **ESTABLISHING THE FIGURE**

Necessary to show the scale and depth of the composition, the figure is added using a medium round sable brush in Payne's grey and Prussian blue. The umbrella is sap green. With the remainder of the green and blue, colour the gate and lighten with white. Drop shadows into the ridges of the fence and guttering.

Use only a fine sable or synthetic brush for this delicate penultimate stage.

Keep the brushstrokes short, light and brushy throughout.

FINAL SNOWY TOUCHES **8**

Squeeze creamy white acrylic straight from the tube and add texture to the snowy areas with a dry brush. These sparkling highlights will give an atmospheric impression so typically found in a Sisley canvas.

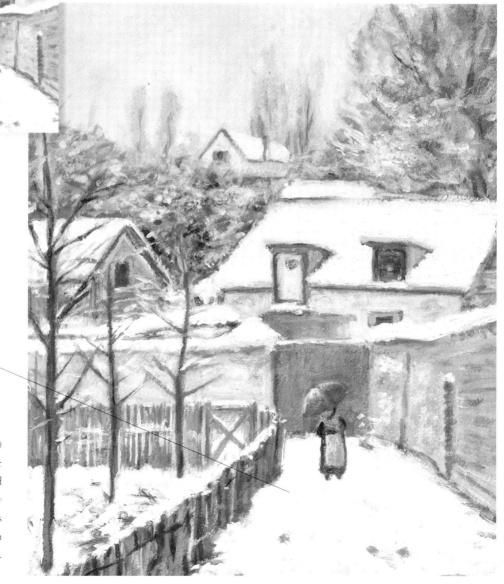

CHA-U-KAO THE FEMALE CLOWN

Lautrec

HENRI DE TOULOUSE-LAUTREC *1864–1901*

Before you begin . . .

Without the benefit of quick-drying acrylic paints, Toulouse-Lautrec applied a technique of extracting the pigment from his oil paint using blotting paper and then transferring it, thinned with turpentine, onto cardboard as a chalky glaze. It was very quick-drying and gave his work the pastel appearance we recognise as so familiar today. A similar look is possible with dry-brush acrylic. After limited preparation, the paint responds to being handled in a variety of ways – thick can be worked easily over thin

and vice versa. Where Toulouse-Lautrec revelled in the transparent interplay of her encircling, netted skirt and midnight-blue dress, he built up scumbles of transparent layers that gave the illusion of floating one on top of another.

Materials needed

1 Basic supplies (page 10)
2 Unprimed cardboard (51 cm x 71 cm/ 20 in x 28 in)
3 Acrylic paints
4 Brushes: bristle brights (Nos. 6, 8)/ bristle filberts (Nos. 6, 8, 10)
5 Red chalk paper

THE PALETTE

The artist had a preference for dull, muted hues over pure bright ones, and obtained stunning effects through his use of mark and colour combinations.

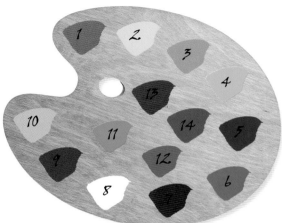

1	Burnt sienna	8	White
2	Cadmium yellow	9	Violet
3	Raw sienna	10	Yellow ochre
4	Bright green	11	Cerulean blue
5	Ultramarine	12	Phthalo green
6	Cobalt blue	13	Burnt umber
7	Payne's grey	14	Lilac

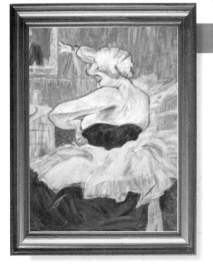

About this painting

Henri de Toulouse-Lautrec was raised in Albi, France, and after studying in Paris, set up a studio in the colourful night district of Montmartre. Bohemian and vivacious, he painted his acquaintances from the local theatres, cabaret bars, circuses and brothels. Often executed on cardboard, his oils reveal a mastery of characterisation, wit, movement and energy, worked very much under the influence of Degas and the alcohol that was to bring about his premature death. Cha-U-Kao was a riotous dancer and clowness at the famous Moulin Rouge and Nouveau Cirque, and in this uncompromising study of 1895, she adjusts her bodice in a private backstage moment. Caught off guard from an unflattering angle, her position emphasises her buxom figure, as witnessed by a curious gent in the reflecting mirror.

TRANSFERRING THE IMAGE

After preparing the template on page 167, use red chalk paper to transfer your traced outline of the main shapes to your sheet of smooth, brown cardboard. Sketch over the shapes with a thin wash of burnt sienna acrylic.

The broadest of outlines should produce a totally adequate underdrawing to work from.

Show movement with the application of gestural marks.

PAINTING IN THE DRESS

The dress comprises almost half of the composition. Lightly sketch the skirt and hair ribbon in cadmium yellow with a touch of raw sienna mixed in; use bright green for the sash. The body is a darker combination of ultramarine, cobalt blue and Payne's grey.

Attempt to follow the form with your brushstrokes on the upper torso. A small round and similar-sized flat-bristle brush will suffice.

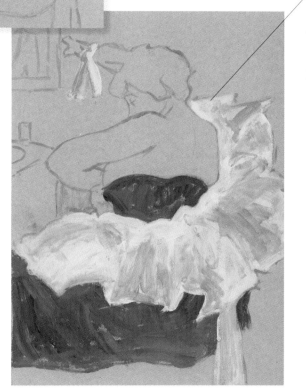

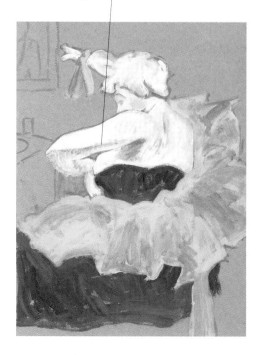

ADDING FLESH TONES AND HAIR

The flesh is built up in thin dry layers with an amazingly broad combination of colours to model the body. Violet and raw sienna form the basis of the shadows; white creates the highlights; cadmium yellow with yellow ochre warms the mid-tone skin. Give the hair a softer quality of mark.

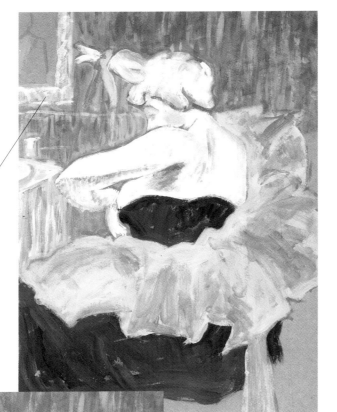

Use a little more white for the table and its objects, and white for the picture frame in the top left-hand corner.

BLOCKING IN THE WALLS

It is broken strokes of paint that make up the walls, cruder and in contrast to the figure. Use cerulean blue and phthalo green alternately in vertical strokes, each mixed occasionally with white.

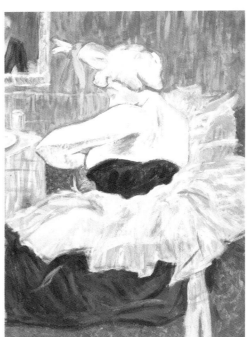

Picking out the occasional detail will help to unify the whole composition without relying on a complete 'finish' to all areas.

REFINING THE ELEMENTS

The dress and sash can be improved with the addition of yellow and white flicks of a small round brush in the direction of the material's folds. The background picture, glass and plate, and blue dress are all enhanced with bolder strokes of Payne's grey, cobalt blue and white.

INCLUDE THE COUCH

The couch, known as a canapé, is sumptuously scumbled in a warm reddish brown made up of burnt sienna, violet, white and a smidgen of burnt umber. It has a mottled surface worked with hatchy strokes.

This line is so important for the redefinition of the various forms in the composition.

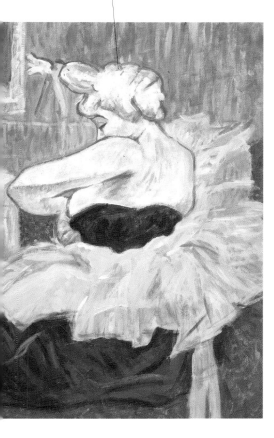

Keep the background strokes strong and lively. Where the dilute paint has sunk a little, re-establish it with the appropriate colours.

A FINAL FLOURISH

Going over selected areas with the brush can make a huge difference to the quality of finish, especially on the clown herself. Her hair grabs the attention because of its finer modelling and colour provided by touches of lilac, bright green and burnt umber.

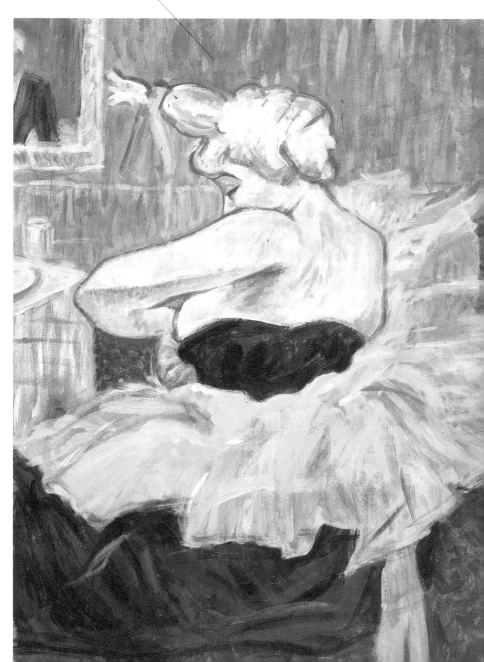

DETAILING FACIAL FEATURES

What can be seen around the nose, eyes and jawline is described with a stronger outline of cobalt blue and Payne's grey. The 'sculpted' hair forms should also receive a tweak to bring clarity to the hairstyle.

THE FIGHTING TEMERAIRE

J M W Turner RA

JOSEPH MALLORD WILLIAM TURNER *1775–1851*

Before you begin . . .

To achieve his atmospheric light effects, Turner adopted an inventive attitude to the undertaking of traditional painting techniques, laying them down on an unorthodox ground of pure white. He mixed his emotive colours directly onto the canvas and depended as much on the use of scumbling as on glazing. Painting the *Temeraire* should be an exciting challenge, and you will need a range of bristle brushes, because the artist's surviving paintbox clearly testifies to his having used the same. Prepare a fairly smooth textured canvas with a white primed surface – acrylic primer or matt emulsion applied to the surface will be adequate.

Materials needed

1 Basic supplies (page 10)
2 Medium-smooth texture (341-g/ 12-oz) duck cotton cotton canvas (46 cm x 76 cm/ 18 in x 30 in)
3 Acrylic primer or

white emulsion
4 Conté pastel: sepia
5 Acrylic paints
6 Brushes: bristle flats (Nos. 10, 12, 15)/bristle rounds (Nos. 6, 8, 10)
7 Red chalk paper

About this painting

☛ *Turner's journey as an artist took him into the shocking domain of abstracted impressions, where he projected the very essence of the natural world onto large canvases in a swirl of light and colour.* The Fighting Temeraire, *1838, is at first glance a radiant oil painting: calm, dramatic, poetic, but on second consideration it is a symbolic elegy of a death at sunset — the death of the* Battle of Trafalgar *warship, clearly pointing towards the noticeable decline of a nation. The horizon is not clear, melting into a liquid gold sea, and the contrast with the white oaken carcass being pulled to her final resting place by the solid full-bodied steam tug reveals most clearly Turner's ability to speak at so many levels with a selective palette and assorted techniques.*

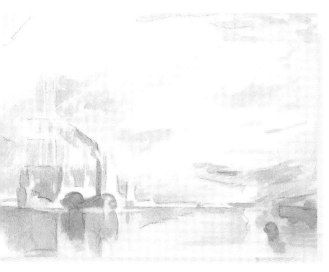

① OUTLINING AND TONING THE CANVAS

Prepare the template using the grid on page 168. Transfer a few simple outlines of the main figurative elements (boats and masts) to the prepared canvas with a sepia conté pastel. Select the main areas of tone in the sky and sea, and block them in with a small round brush loaded with a light wash of burnt sienna.

The laying of early washes can be freely spread across the canvas to initiate a textured sky.

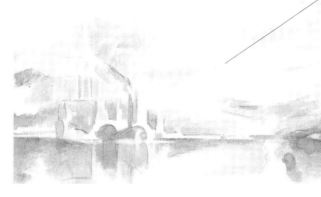

COLOURING THE SKY ②

Drop light washes of diluted ultramarine acrylic into the sky, and add in a hint of cerulean blue to enrich the tint. While they are both still wet, work them into the canvas with your fingers to produce a scumbling effect.

Simple washes of cadmium and lemon yellow can have an enormous impact on the colour cast of the canvas.

Painter's Pointer

The luminosity of Turner's canvases is determined by the build-up of thin, pure colour, allowing reflected light to pass through the transparent washes.

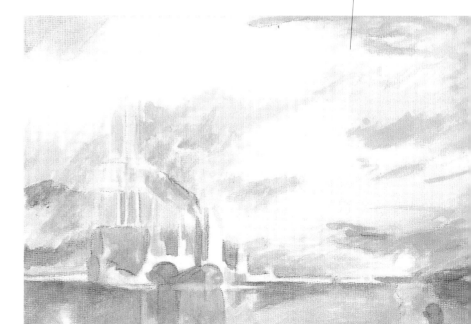

WARMING THE ATMOSPHERE ③

Scumble cadmium and lemon yellow across the sea and sky with a larger round bristle brush, allowing the primed canvas, sienna and blue underpainting to show through.

SILHOUETTING THE KEY ELEMENTS ④

In contrast to the general lightness of the picture, add the heavier shadowy structures of the tug and buoy using a mix of burnt umber and black. Employ this same mix to deepen the foreshore at the base of the picture.

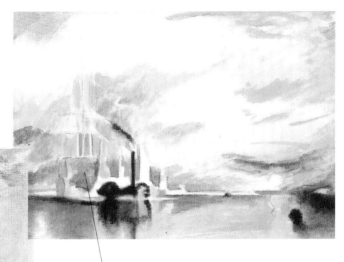

The contrast between the tug and the hull of the ship looming large behind creates a ghosting impression.

⑤ DEEPENING THE SUNSET

Use the reds in your palette – cadmium red, cadmium orange and burnt sienna – to ignite the cloud forms and glassy surface of the water. The addition of these tones will also help to establish a strong horizon.

Add white back into the clouds to increase their density.

REFINING THE SCENE ⑥

Take a broad flat brush and scumble a mixture of dry and wet paint into the lightest areas of the canvas. Blend lemon yellow into the clouds, cobalt blue into the lower sky, and Payne's grey into the shadows and undersides of the clouds.

7 ADDING DETAILS

Lift the details with a fine sable brush using white, burnt sienna and yellow ochre. Delineate the masts and rigging, fluttering flag and panelling on the sides of the ship with a combination of the three.

The scene is suddenly brought to life with the introduction of finer detail.

FINISHING TOUCHES 8

Additional ripples in the water, highlights on the masts and rigging, and a scumbled wash of yellow ochre to soften the reflections all help generate a higher level of realism to counterbalance the imaginative approach to the light and atmosphere of the evening.

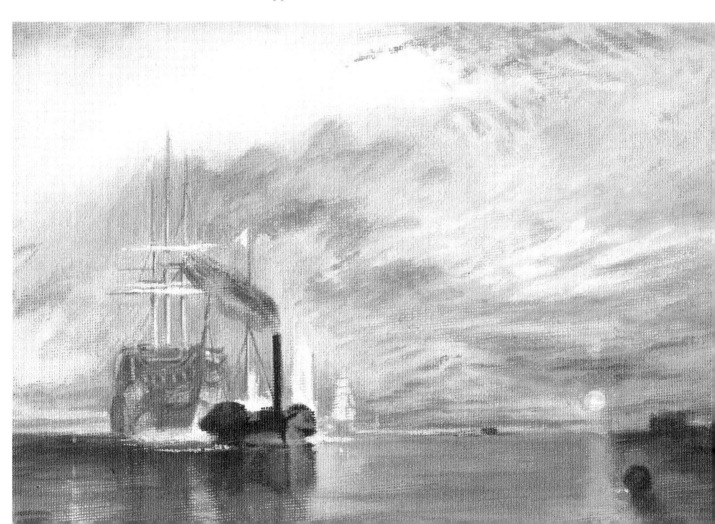

WHEATFIELD WITH CYPRESSES

Vincent

VINCENT VAN GOGH 1853–1890

Before you begin . . .

The turbulence of Van Gogh's restless life gave rise to remarkable waves of passion and energy, surfacing in swirling marks of thick, vibrant paint. This unique treatment sets his art in a class of its own, highly charged with nervous emotion but finding solace and technical influence in the spiritual serenity of Japanese prints. With these in mind, you will need to create your own version of the picture on a slightly coarse-textured canvas, balancing a broad underpainting against controlled, vigorous brushstrokes and strong, linear outlines to heighten the illusion of depth. Gather a selection of short-bristled flat and round brushes that will work well together.

Materials needed

1 Basic supplies (page 10)
2 Slightly coarse texture (227-g/ 8-oz) duck cotton canvas (46 cm x 31 cm/ 18 in x 12 in)
3 Acrylic paints
4 Brushes: bristle flat (No. 8)/ bristle round (No. 4)/broad bristle filbert (No. 6)
5 Red chalk paper

THE PALETTE

The high-key colours of Van Gogh's palette reflect the heat of the Mediterranean sun, but the combinations hold the tensions of a passionate yet fragile artist.

1 Yellow ochre	7 Ultramarine
2 Cadmium yellow	8 Crimson
3 Bright green	9 Burnt sienna
4 Phthalo green	10 Burnt umber
5 Cerulean blue	11 Lemon yellow
6 White	

About this painting

Van Gogh left Paris in 1888 and settled in the peaceful surroundings of Arles. At the time, he was living in an asylum at Saint-Remy and wished to consolidate his intense feelings about the people and ordinary objects surrounding his inner world, which led to the use of light, decorative colours and distorted forms. In 1889 he responded to the landscape with Wheatfield with Cypresses, an oil study that expresses strong directional movement. The tree licks the sky as a tormented flame; bushes writhe, wheat ripples, and agitated clouds billow around the pale, open sky. The atmosphere mirrors a painting he had seen by John Millais, which portrays the greyness of approaching autumn. Summer replaces the autumn, a mistral blows and the mood is uneasy.

① PREPARING THE CANVAS

Prepare the template using the grid on page 169. The preparation of a primed white canvas should begin with a light wash of yellow ochre to mute the stark whiteness of the surface. Use red chalk paper to transfer the basic traced outlines to the canvas.

② BLOCKING IN THE GROUND

The strong colour of the wheatfield in the foreground of the picture owes much to the strong wash of cadmium-yellow tint in this first layer.

Using cerulean blue, bright green and white, counterbalance the cypresses by making a feature of the olive tree in the middle left of the picture.

Make sure that the yellow is laid thinly so as not to obscure the outlines.

BLOCKING IN TREES AND BUSHES ③

Consider the cypress trees and their surrounding shrubbery as a middle strip of interlocking shapes, and block them in with bright green and phthalo green. Wash a broad, loaded flat-bristle brush of yellow ochre over the greenery in the foreground and middle distance.

The strokes are all being laid down in a strong horizontal direction to the right.

④ DEVELOPING AERIAL PERSPECTIVE

This occurs where an artist has deliberately chosen to use cooler hues and tones to show elements receding into the background and vice versa. Model the distant hills lightly in rolling marks of ultramarine and cerulean blue.

The pure white of the clouds gives strong contrast and divides the composition into two working halves.

INTRODUCING CLOUDS TO THE SCENE ⑤

The clouds dash across the scene, mirroring the shapes on the ground. At this stage do not be too specific; denote them roughly, in preparation for the next stage.

The row of clouds nudging up from behind the hills follows the undulating course of the hills.

⑥ WORKING AT THE SKY

With a broad filbert flat-bristle brush, begin to express the sky as a boiling mass of slurring shapes in cerulean blue, white and bright green. The forms themselves are ultramarine, crimson and white. The addition of crimson delivers an extra warmth of the sun as it is hidden behind the clouds.

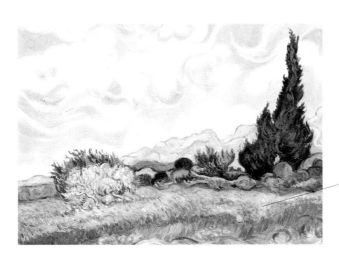

7 FINER DETAIL

The small vertical strokes for which Van Gogh was so well known are painted into the wheatfield, and a sense of depth is achieved with yellow ochre, burnt sienna and burnt umber. Highlights are added with an unusual mix of lemon yellow, cadmium yellow and white.

Yellow ochre harmonises with the green of the cypress trees to create more depth and further modelling of the foliage.

UNIFYING THE COMPOSITION 8

To define the olive tree, use cerulean blue, bright green and white. The branches on the shrubs are in phthalo green. The cypress trees lick up to the sky with dashes of phthalo green, yellow ochre and ultramarine. The contrast of the bushes against the hills is toned down with a yellow ochre and bright green wash.

Strengthen the whole painting by looking at the compositional elements and darkening them down where necessary.

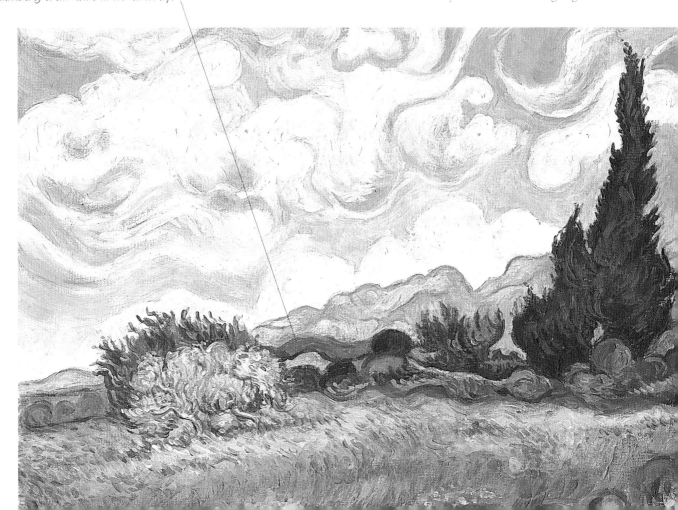

SUNFLOWERS

Vincent

VINCENT VAN GOGH 1853–1890

Before you begin . . .

Thick impasto brushstrokes burst forth into simple blooms that twist in all directions, and agitated on the surface, they seem to reveal the artist's desperate state of mind. The energy of these marks needs to be captured in your copy, as does the placing of correct tonal and colour values. Beauty is the overriding factor here. 'I don't mind so much whether my colour corresponds exactly, as long as it looks beautiful on my canvas,' remarked Vincent as he boldly experimented with strong, unorthodox colour combinations to release the emotive power he saw rooted in nature. Enjoy the sensory pleasures of painting directly from the tube – impasto.

Materials needed

1 Basic supplies (page 10)
2 Medium-to-coarse hessian canvas (61 cm x 71 cm/ 24 in x 28 in)
3 Acrylic paints
4 Brushes: bristle flats (Nos. 6, 8, 10)/bristle rounds (Nos. 4, 6, 8)
5 2B pencil
6 Charcoal
7 Tracing paper

THE PALETTE

This vibrant study has a very limited but carefully chosen colour range, dominated by earthy pigments, which complement the green stalks and yellow blooms.

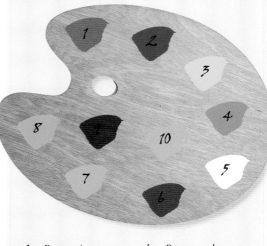

1	Burnt sienna	6	Burnt umber
2	Raw umber	7	Sap green
3	Cadmium yellow	8	Bright green
4	Raw sienna	9	Payne's grey
5	White	10	Yellow ochre

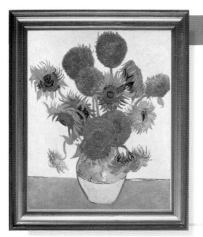

About this painting

☞ 'I hope I have landed on my feet this time, you know — yellow outside, white inside, with all the sun, so that I shall see my canvases in a bright interior,' wrote Vincent to his brother Theo on May 1, 1888, having just rented the Yellow House in Arles, southern France. He intended it to be the embodiment of his ambition as a place where painters could work together, and he set about gradually furnishing and decorating his new dwelling as money allowed. In August, anticipating Gauguin's arrival to share the house, he painted the first of ten versions of Sunflowers. Yellow certainly held power over him. Sunflowers were to become his symbol, as fresh on the canvas as those in the surrounding fields, and painted with all the vigour of a man who yearned for the hope that the blossoms of sunlight can bring.

The fiery heart of this painting owes much to the glow of the washed canvas.

❶ PREPARING THE CANVAS

A reddish base should be prepared for this painting by dropping a thin wash of burnt sienna and raw umber across the whole surface of the canvas. Prepare the template following the grid on page 170.

❷ ESTABLISHING THE OUTLINE

Trace the drawing directly onto the canvas using a 2B (or softer) pencil and then strengthen this with charcoal so that it stands out.

Alter the pressure of your charcoal stick so that the variation of line – thick and thin, light and dark – gives the drawing an illusion of light.

In contrast, apply thicker paint in raw umber and burnt umber to the table surface, thus establishing a middle tone.

BLOCKING IN THE BACKGROUND ❸

The wall behind the vase deliberately has the lightest tone to allow full attention to fall on the sunflowers. Paint it reasonably flat with a mixture of cadmium yellow, a tiny amount of raw sienna and white. Using a dry brush, the primer colour and marks will show through, giving it texture.

DESCRIBING THE BLOOMS ④

Give the painting impact with the large brown seed heads of raw sienna, burnt umber and burnt sienna. Apply the paint thickly with a small round bristle brush whose marks radiate from the centre of each flower.

Keep your flower heads simple with no fussy petal descriptions.

Begin to highlight your picture with white softened by raw umber and pale green.

⑤ **ADDING THE STALKS AND LEAVES**

With creamy quantities of sap green and bright green, outlined with Payne's grey, develop the leaf and stalk shapes using the same small round brush.

Let the brush do all the work. The bristles will naturally carve a path through the paint and leave light ridged lines, as found on the surface of petals.

⑥ **DETAILING THE PETALS**

The flower petals can be easily formed by spreading a small round brush through the blend of raw sienna, yellow ochre, cadmium yellow and burnt sienna.

Notice how the lighter-toned base of the vase contrasts effectively with the darker-toned table, setting up the illusion of three dimensions without the need for shadows.

7 ESTABLISHING THE VASE

Van Gogh's vase is as memorable in its shape as his sunflowers. It is a familiar earthenware piece of two colours. The top half should be painted with raw sienna, and the lower half yellow ochre and white, outlined in burnt umber.

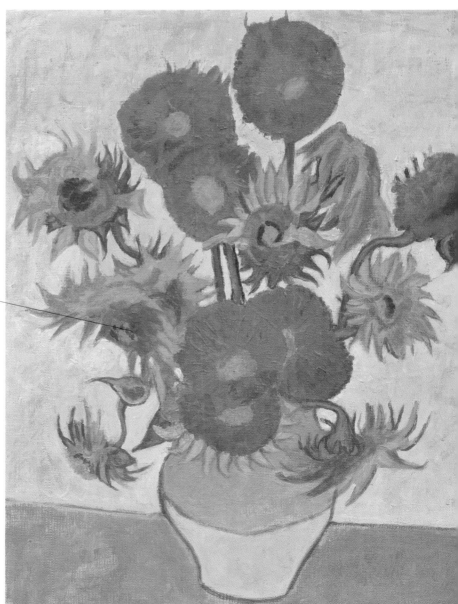

Lastly, drag the residue of dry paint from your palette lightly across the surface to allow the underlying colours to show through.

FINISHING TOUCHES 8

Naturalise the whole painting by knocking back the background yellows with a dry blend of white, yellow ochre and cadmium yellow. Enhance the shapely definition of the flower petals with burnt sienna and the darker Payne's grey.

CHAIR AND PIPE

Vincent

VINCENT VAN GOGH *1853–1890*

Before you begin . . .

The mark of a true master can be fully appreciated when he is able to sweep power and emotion through the strokes of a familiar domestic subject that you and I might choose to tackle on a day when we cannot find higher inspiration! This picture certainly uses a calmer, more harmonious palette, with more controlled flecks of the brush, and you will require a charcoal pencil to assist the laying down of a strong key line. You will need to purchase a coarse-weave canvas (or hessian if preferred).

The painting is best accomplished with a range of flat and round brushes – a No. 8 is best for sweeping impasto strokes, while a No. 4 gives room for drier, detailed layering.

Materials needed

1 Basic supplies
 (page 10)
2 Coarse-weave or
 hessian canvas
 (51 cm x 41 cm/
 20 in x 16 in)
3 Acrylic paints
4 Charcoal pencil
5 Brushes: bristle
 flats (Nos. 6, 8,
 10)/bristle rounds
 (Nos. 4, 6, 8)
6 Red chalk paper

THE PALETTE

Van Gogh's choice of hues reflects his sense of stability and contentment with his new sunny residence. Choosing thinner acrylic paints than Vincent's original oils will more than halve the drying time.

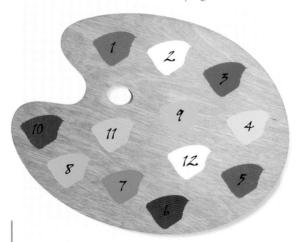

1	Burnt sienna	7	Cerulean blue
2	White	8	Bright green
3	Cobalt blue	9	Yellow ochre
4	Cadmium yellow	10	Cadmium red
5	Raw sienna	11	Flesh tint
6	Burnt umber	12	Lemon yellow

About this painting

☞ *Vincent's new life in Arles was destined to be a domestically very simple one. He had left Paris for the tranquillity of country life and to reacquaint himself with a practice he had always loved, that of recording rural workers. The lack of clutter has enabled all who now view Van Gogh's wonderful interior paintings to focus on the man as displayed through his chattels. The pipe and tobacco poised on the chair perfectly express humanity and add a personal touch to what might otherwise be perceived as an ordinarily simple study. Many of his later paintings are devoid of figures, replaced instead by objects as personified through his inimitable use of colour and brush mark. The strange angle at which the floor tilts towards us is a deliberate device to give the chair extra poignancy, thus making us more aware.*

① PREPARING THE CANVAS

A coarse, primed white canvas should be washed with burnt sienna of medium strength. To cover your area rapidly and as easily as possible, use a broad brush. Prepare your template using the grid on page 171. Secure the red chalk paper onto the canvas and push the tracing of the drawn outline through to the primed surface. Strengthen the outline using a charcoal pencil.

Check that you have established the peculiar tilt of the floor, even though in charcoal line it seems to glare as an error.

This important passage of blue helps to define both the chair and earth-brown tiled floor. Its flatness, tone and colour are completely in contrast to them.

② BLOCKING IN THE BACKGROUND

Take your medium-sized brush and fill the wall behind the chair with an opaque block of light blue, made up of cobalt blue and white.

Allow the burnt sienna to show through the built-up layers. The patchy streaking mimics grainy wood.

ESTABLISHING INTERIOR OBJECTS ③

Cadmium yellow provides the base hue for the chair and bulb box, sited on the far left edge of the canvas. Van Gogh worked these areas with layers of wet-in-wet pigment.

④ FILLING IN THE FLOOR

A clear tonal divide establishes the solid tiled floor. It is darker on the left-hand side, where a shadow is cast underneath the frame of the chair. Paint raw sienna to the right and a mix of burnt sienna and burnt umber to obtain the darker hue on the left.

The grouting in between the tiles is achieved with the small brush and blended marks of cadmium yellow, white and bright green.

Don't cover the charcoal pencil beneath the floor completely. You need a guide for the placement of tiles.

For the look of stone floor tiles, apply thickly brushed strokes of cadmium red with white, flesh tint, yellow ochre, bright green and burnt sienna. Mix these colours directly onto the canvas.

ADDING DETAIL AND TEXTURE ⑤

Select a small round bristle brush and tip the surfaces with impasto acrylic textures. Cerulean blue and white make a strikingly raw wall coat. The finer pattern of the chair seat is constructed with painterly strands of bright green, yellow ochre and burnt sienna, which are brushed in the same direction as the weave.

Take a medium flat-bristle
brush and unify the overall
tones with the barest hint of
raw sienna and yellow ochre.

Apparently, the motifs of
pipe and tobacco were not
conceived in the original
composition but were added
by Vincent much later,
when the paint was dry.

FINE DETAIL AND FINISHING TOUCHES 6

It is the finer details that will really characterise your Van Gogh copy. His decisive strokes reinforcing the outlines with creamy, wet paint were added at this stage to the chair weaving using an unusual blend of green and raw sienna. Brighten the room by lightening the floor tiles with white, bright green and raw sienna, and paint in the pipe and tobacco along with the sprouting bulbs in the box. To help the chair stand out from its background, a pale blue hue is formed from cerulean blue, cobalt blue and white, and this is drawn over the outlines of the chair. To help brighten the colours and define the textures, move across the canvas adding streaks and flecks of bright green, white, lemon yellow and cadmium red.

GIRL WITH A PEARL EARRING

I.Ver-Meer

JAN VERMEER 1632–1675

Before you begin . . .

The thought and mystery displayed in the poetry of Vermeer's sitter is typical of the artist's approach. He quietly sought to execute simple, engaging scenes of everyday life using soft, radiant colours, freely blending across the canvas but with no precise lines. You will need to practise subtlety of mark with delicacy of mixed colours to achieve Vermeer's sense of painting with light as it falls on the stillness of the subject. The canvas should be prepared with a dilute mixed wash of white, Payne's grey and raw sienna acrylic paint before you transfer your tracing. A selection of bristle brushes will provide your main strokes, but for soft blending of fabric and features, a fine sable or synthetic brush is required.

Materials needed

1 Basic supplies (page 10)
2 Smooth-texture (426-g/15-oz) duck cotton canvas (41 cm x 61 cm/ 16 in x 24 in)
3 Acrylic paints
4 Brushes: bristle flats (Nos. 8, 10, 12)/sable rounds (Nos. 2, 4, 6)
5 Red chalk paper

THE PALETTE

To create the dramatic, pearlised lighting effects that gave Vermeer his inimitable signature, use this limited palette of exquisite colours.

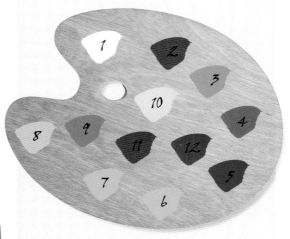

1	White	8	Flesh tint
2	Payne's grey	9	Crimson
3	Raw sienna	10	Cadmium yellow
4	Burnt sienna	11	Burnt umber
5	Prussian blue	12	Cadmium red
6	Sap green		
7	Yellow ochre		

About this painting

Jan Vermeer marks the high point of 17th-century Dutch genre painting. The peaceful expressions of lone women going about their domestic chores in semi-lit interiors evoke the earlier work of fellow countryman Jan van Eyck, and the dynamic use of chiaroscuro is reminiscent of Rembrandt. Girl with a Pearl Earring, 1665, is one of Vermeer's most lucid paintings, enhanced by the harmony of blue and yellow oil tones threading themselves throughout the composition. Against the receding dark background, the three-dimensional effect of the portrait is enhanced. Using thinned oil glazes, he gently modelled the blurry features of the eyes, lips and nose, achieving a fresh, clear luminosity on the girl's face as she is apparently caught in a distracted moment.

① PREPARING THE CANVAS

The base mix of white, Payne's grey and raw sienna should be smoothly and lightly scumbled evenly over the whole surface in readiness for the subtle build-up of glazes. Prepare the template using the grid on page 172, and transfer the outline of the image onto the canvas with red chalk paper.

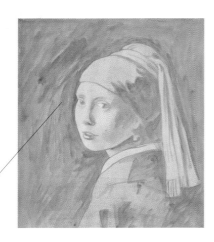

② LAYING THE OUTLINE

Sketch the soft outline of the girl using slightly thinned burnt sienna. White should be used to blend into the highlighted areas of the face and for defining the head shape.

Gently blend white into the burnt sienna to lighten the tones. Use your flat brushes to achieve Vermeer's softness.

ADDING THE HEADDRESS AND COSTUME ③

Add Prussian blue to the headdress and sap green with yellow ochre to the costume using gentle strokes that follow the forms. Be bold when adding the shadow areas onto the headdress, shoulder and beyond. Apply it with deep intensity of hue – this will trigger the illusion of three dimensions.

Begin applying highlights with yellow ochre and white.

TINTING THE FLESH ④

The warmth of the face is modelled using flesh tint, and a tiny squeeze of crimson and pale cadmium yellow to help it glow. Blend the hues directly onto the canvas using a small, flat hog-hair or bristle brush so as to eradicate hard edges.

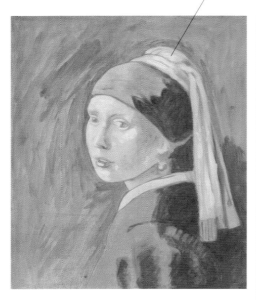

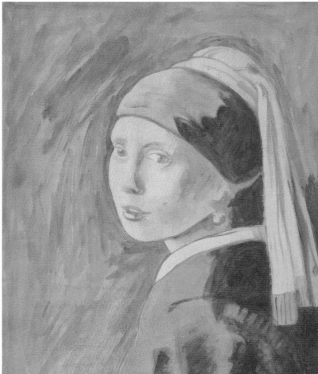

5 CREATING THE BACKGROUND

Strokes of Prussian blue mixed with
burnt sienna and burnt umber must now
be blocked in with a broader bristle brush,
as shown on the numbering scheme.

*These hues can also
be used to deepen the
folds of the turban.*

6 WORKING IN THE DETAILS

Allow the acrylic to dry before modelling
the finer details in the headdress with
drier highlights of white and yellow
ochre. These should be modelled with
a fine sable or synthetic brush.

*Add burnt sienna
and Prussian blue
to the inside of the
folds of the turban
to give them
greater realism.*

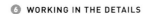

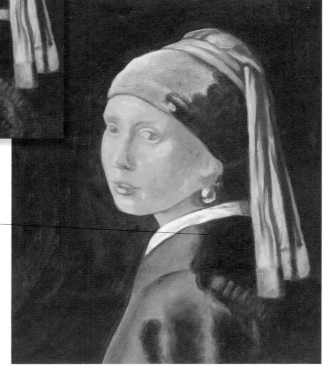

*While the brush
marks are still
wet, blend with the
tip of a finger.*

FURTHER SOFTENING 7

To achieve the velvety softness of Vermeer's fabric,
use the combined hues of sap green and burnt sienna
with touches of Prussian blue brushed deep into the
clefts of cloth. At this stage, add white and a smidgen
of Prussian blue to the earring and collar.

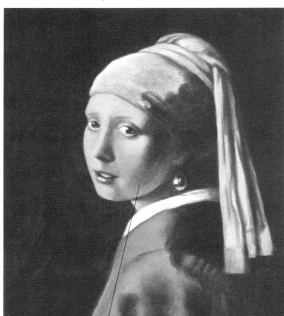

8 EXTRA SHADOW TONES

Create further realism and the dramatic contrasts, for which Vermeer is renowned, by washing thin glazes of raw sienna, burnt umber and burnt sienna over the shadow areas of the cheek, jaw, neck and inside line of the nose.

Use only a fine sable or synthetic brush for this delicate penultimate stage.

FINISHING TOUCHES 9

Gloss the lips with cadmium red, and use this stunning hue diluted and applied as washes to warm the skin tones. Intensify the eyes with a strong black and burnt-umber mix, and use this on the receding shadow of the neck and pearl earring, too. Final highlights to the eyes and earring in pure white will conjure the final magic sparkle.

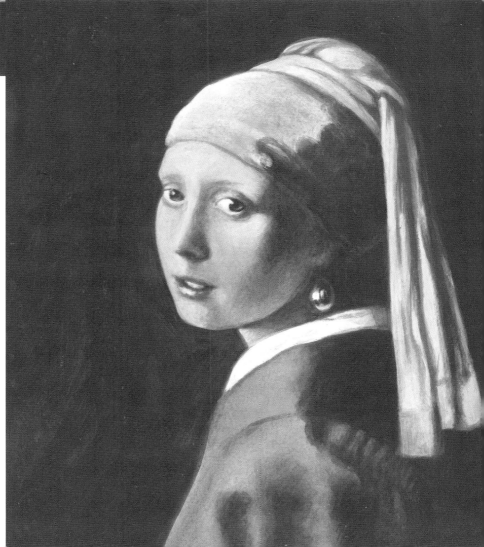

PORTRAIT OF THE ARTIST'S MOTHER

J A M E S W H I S T L E R *1 8 3 4 – 1 9 0 3*

Before you begin . . .

Whistler translated two-dimensional qualities, tonal values and edited details into highly individual treatments of colour harmony and tone on a flat, decorative surface. Musical titles express the spare use of colour 'notes' on dimly lit canvases that are their stave. To succeed in copying Whistler, you will need to play the notes gently with your brushes. The impressions you build up with shapes and colour will determine the sound that your final composition makes. The canvas for this picture is a little off square

along its width, making it landscape in format, and a 41-cm x 46-cm (16-in x 18-in) stretcher should be fine for the job. It is exceptionally ornate in the broader areas, where the detail exists in the portrait.

Materials needed

1 Basic supplies (page 10)
2 Medium-smooth texture (341-g/ 12-oz) duck cotton canvas (41 cm x 46 cm/16 in x 18 in)
3 Acrylic paints
4 Brushes: bristle flats (Nos. 6, 8, 10) /sable rounds (Nos. 1, 2, 4)
5 Red chalk paper

THE PALETTE

The overwhelming sense of blacks and greys in this composition should by rights make it dull and flat. But clever use of the earth pigments, harmonising them with blue greys and green and playing them against the starker whites and flesh tints, makes it work.

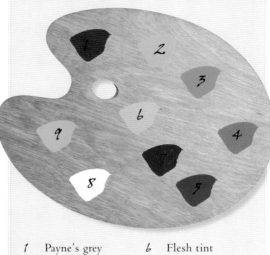

1 Payne's grey
2 Sap green
3 Raw sienna
4 Burnt umber
5 Raw umber
6 Flesh tint
7 Cadmium red
8 White
9 Yellow ochre

About this painting

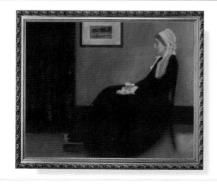

James Whistler left the United States in 1855 to visit Paris, where he trained in the realist tradition of Courbet. When his early works began to receive acclaim in England, he settled in London in 1859 and engaged himself in capturing its most enduring subject, the Thames River. Although best known for these gauzy impressions, he also painted portraits, perhaps the most memorable being of his mother. She first posed for three days but, when this proved tiring, adopted the sitting position for the duration of the portrait, a further three months. Shown in the 1872 Royal Academy exhibition, it received mixed reviews. Caring little about criticism, Whistler interested himself only in the arrangement of outlined shapes, detailed contrasts of light and an overall tonal unity.

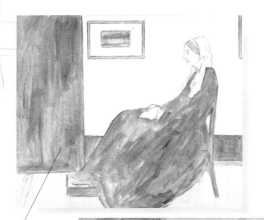

❶ ESTABLISHING THE OUTLINE

Prepare the template using the grid on page 173. Transfer the outline to the canvas using the red chalk paper and then block in all the main dark shapes (including the figure) with a thinned-down wash of Payne's grey. Make sure that your canvas is supported at a very shallow angle or on the flat to avoid the paint mixture running down the surface and dripping onto the floor.

The thinned Payne's-grey wash allows the underdrawing to show through.

❷ SELECTING THE MID TONES

Wash over the mid-tone areas – walls, floor, picture mount – using a mixture of sap green, Payne's grey, raw sienna and burnt umber.

At this stage the paint does not need to lie flat on the canvas but should be transparently thin. Remember to leave the first wash around the face and hands showing through.

The overall balance of the composition is now becoming very evident through the contrasts of shape.

❸ DARKENING THE DARKS

Rework the darker sections of the portrait, curtain, skirting board and dress, and strengthen them with a heavier palette of burnt umber, Payne's grey and a little raw umber.

④ ADDING DETAIL

Add some detail with flesh tint, cadmium red and raw umber using a small round sable brush. Use flesh tint mixed with white and a small amount of Payne's grey to loosely denote the lace.

The lace is predominantly white but dimmed by the added tones of grey and flesh.

⑤ DEEPENING THE BACKGROUND

The walls and floor are darkened further with a wash of burnt umber, sap green and Payne's grey, blended using a finger in a vertical direction for the walls and horizontal for the floor.

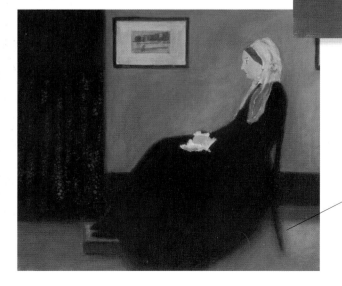

Check for subtle shadows where they are cast by the figure beneath the chair and across the skirting board.

DECORATIVE PATTERNS ⑥

Whistler understated the patterns in this picture. To achieve this, simply dab the shapes you see onto the surface with flesh tint and burnt umber. At this stage, brighten the picture mount with a blend of yellow ochre and white. To give the curtains and dress the illusion of being pleated and folded, smudge in yet more Payne's grey with a small flat-bristle brush and blend the pattern to become part of the background material.

7 FINER DETAIL

Use the dry-brush technique to render the lace with a fine sable round brush in order for the folds of the underlying material to show through. Apply off-white highlights sparingly, directly from the tube.

The minute highlights are powerfully deployed to grab the attention from the low-key tones.

UNIFYING THE COMPOSITION 8

The master strokes to hands and face can be added now using raw umber, burnt umber, white and cadmium red. Any outlines still showing through should be tidied up with soft brushwork.

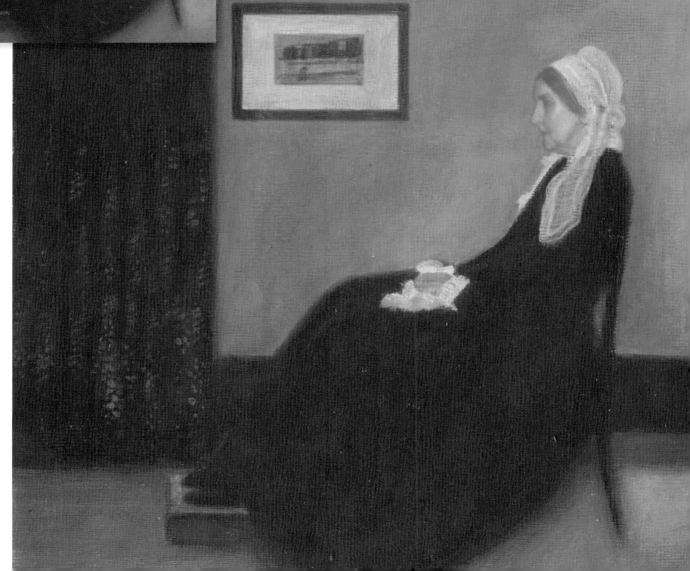

THE TEMPLATES

BOTTICELLI *THE BIRTH OF VENUS* pages 22–25

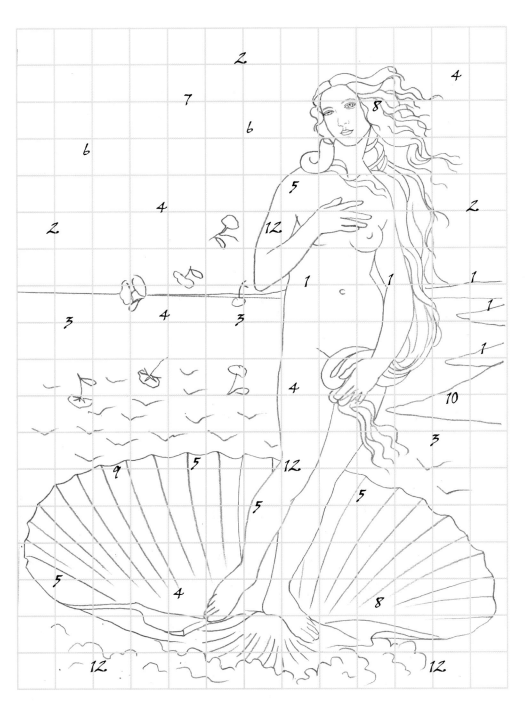

1 Yellow ochre

2 Prussian blue

3 Sap green

4 White

5 Flesh tint

6 Payne's grey

7 Cobalt blue

8 Cadmium yellow

9 Burnt umber

10 Black

11 Crimson

12 Burnt sienna

CÉZANNE *KETTLE, GLASS,*
AND PLATE WITH FRUIT pages 26–29

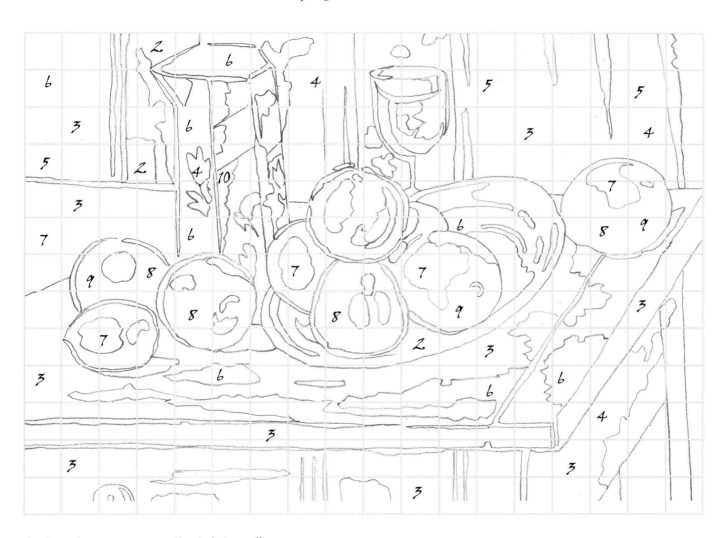

1 Cream/putty	*7* Cadmium yellow	
2 Ultramarine	*8* Cadmium orange	
3 Raw sienna	*9* Cadmium red	
4 Sap green	*10* Violet	
5 Payne's grey	*11* Flesh tint	
6 White	*12* Burnt sienna	

CÉZANNE *MONT SAINTE-VICTOIRE* pages 30–33

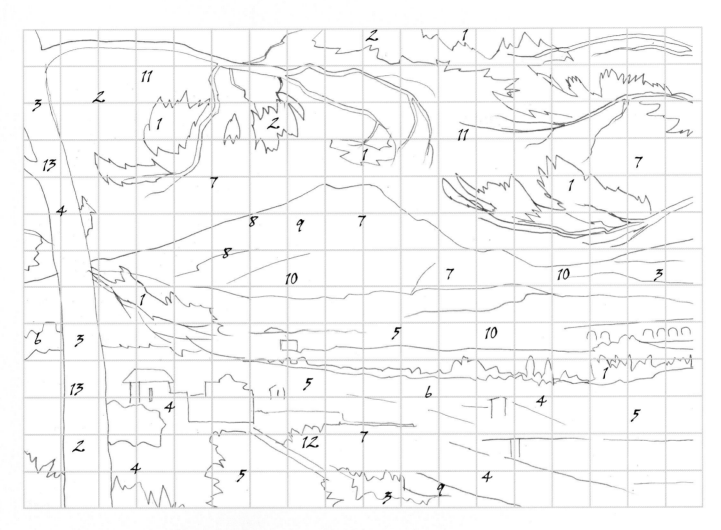

1 Sap green	*6* Cerulean blue	*11* Violet
2 Yellow ochre	*7* Prussian blue	*12* Ultramarine
3 Burnt sienna	*8* White	*13* Payne's grey
4 Cadmium yellow	*9* Cobalt blue	
5 Bright green	*10* Cadmium red	

DEGAS *THE DANCE EXAMINATION* pages 34–37

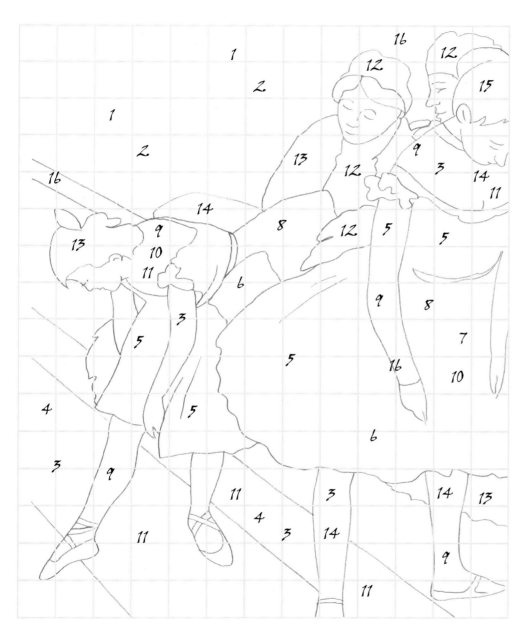

1 Yellow ochre
2 Cadmium yellow
3 Cream
4 Light grey
5 White
6 Turquoise
7 Lilac
8 Light blue
9 Pink
10 Ultramarine
11 Light green
12 Black
13 Sepia
14 Light brown
15 Burnt sienna
16 Bright red

DEGAS *L'ABSINTHE* pages 38–41

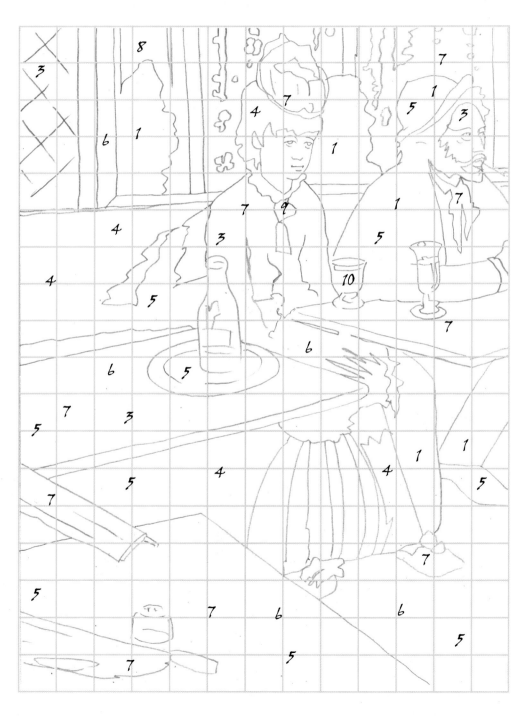

1 Burnt umber

2 Raw umber

3 Flesh tint

4 Burnt sienna

5 Payne's grey

6 Yellow ochre

7 White

8 Violet

9 Cadmium yellow

10 Bright green

DÜRER *HANDS OF THE APOSTLE* pages 42–45

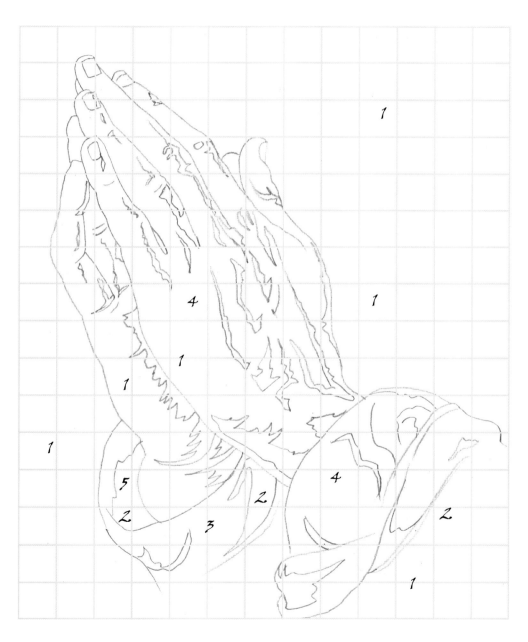

1 Ultramarine
2 Payne's grey
3 Violet
4 White gouache
5 Black

GAUGUIN *TWO TAHITIAN WOMEN* pages 46–49

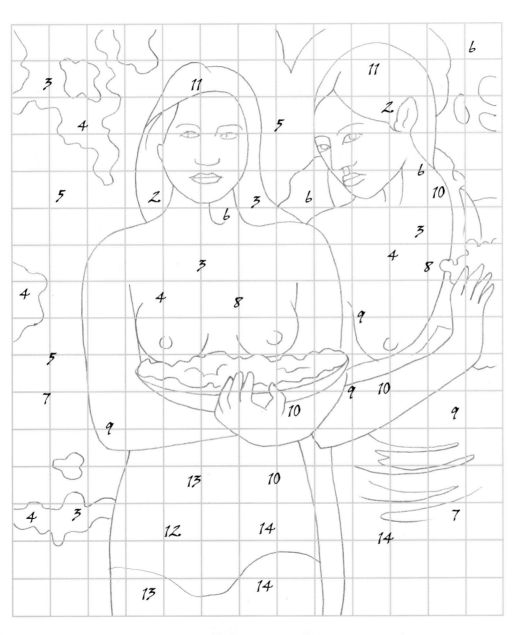

1 Raw umber
2 Burnt sienna
3 Yellow ochre
4 Cadmium yellow
5 Phthalo green
6 Bright green
7 Cerulean blue
8 Crimson
9 Light green
10 Violet
11 Burnt umber
12 Ultramarine
13 Cadmium red
14 White

GAUGUIN *STREET IN TAHITI* pages 50–53

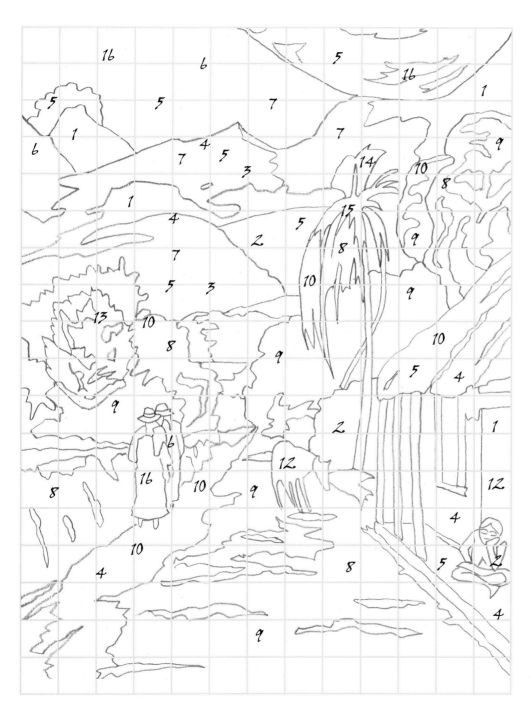

1 Payne's grey
2 Burnt umber
3 Crimson
4 Yellow ochre
5 White
6 Cobalt blue
7 Violet
8 Bright green
9 Sap green
10 Cadmium red
11 Cadmium yellow
12 Burnt sienna
13 Lilac
14 Lemon yellow
15 Raw sienna
16 Ultramarine

HOPPER *NIGHTHAWKS* pages 54–57

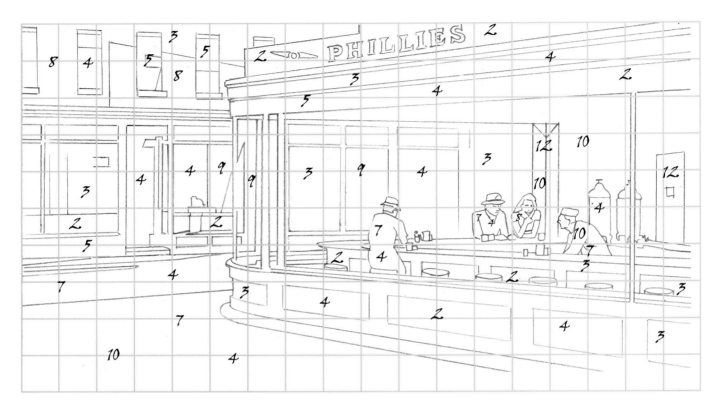

1　Cream

2　Burnt sienna

3　Burnt umber

4　Payne's grey

5　Phthalo green

6　Sap green

7　Prussian blue

8　Cadmium red

9　Ultramarine

10　White

11　Cobalt blue

12　Yellow ochre

KLIMT *THE KISS* pages 58–61

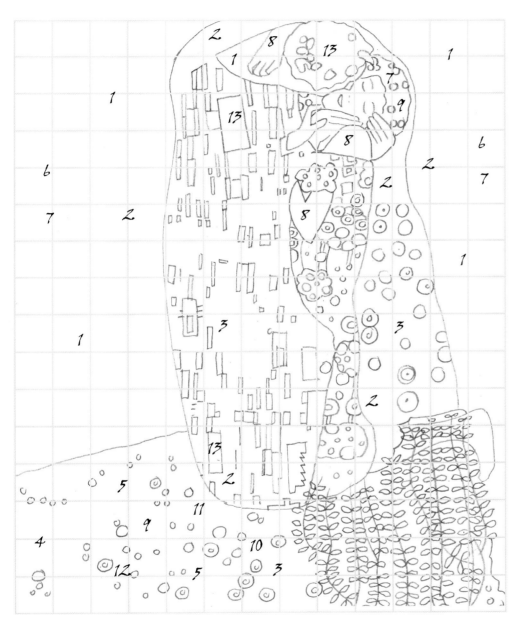

1 Yellow ochre

2 Cadmium yellow

3 Lemon yellow

4 Bright green

5 Sap green

6 Raw sienna

7 Burnt umber

8 White

9 Orange

10 Ultramarine

11 Crimson

12 Lilac

13 Payne's grey

14 Cadmium red

MARC *LITTLE BLUE HORSE* pages 62-65

1 Crimson	*7* Ultramarine
2 Yellow ochre	*8* Payne's grey
3 Lemon yellow	*9* White
4 Cadmium red	*10* Cadmium orange
5 Sap green	*11* Violet
6 Cobalt blue	

MILLET *THE GLEANERS* pages 66–69

1 Yellow ochre

2 Burnt umber

3 Burnt sienna

4 Cobalt blue

5 White

6 Phthalo green

7 Cadmium red

8 Payne's grey

9 Sap green

MODIGLIANI *JEANNE HEBUTERNE* pages 70–73

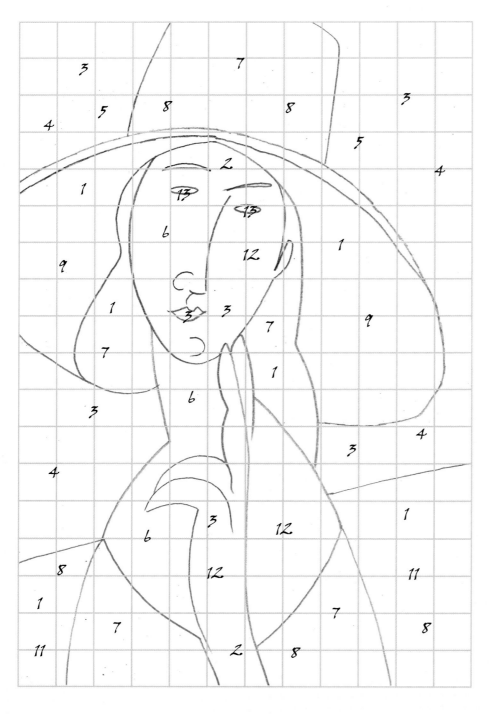

1 Burnt sienna

2 Yellow ochre

3 Cadmium red

4 Cadmium orange

5 Lilac

6 White

7 Burnt umber

8 Payne's grey

9 Raw sienna

10 Cadmium yellow

11 Phthalo green

12 Flesh tint

13 Ultramarine

MONET *WATER LILIES* pages 74–77

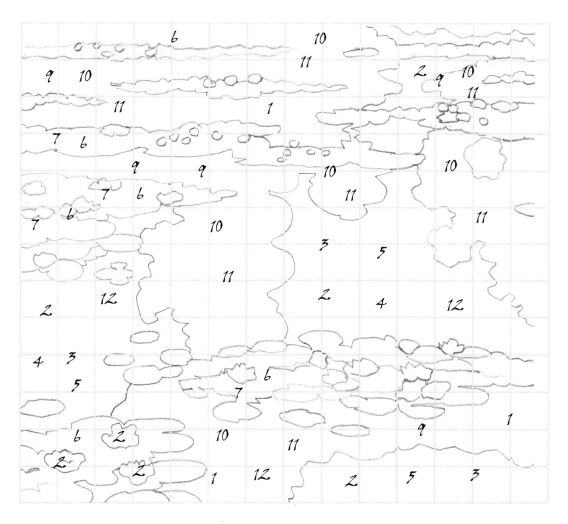

1 Payne's grey

2 White

3 Cadmium yellow

4 Flesh tint

5 Crimson

6 Bright green

7 Sap green

8 Yellow ochre

9 Burnt umber

10 Phthalo green

11 Cobalt blue

12 Lilac

13 Lemon yellow

MORISOT *THE CRADLE* pages 78–81

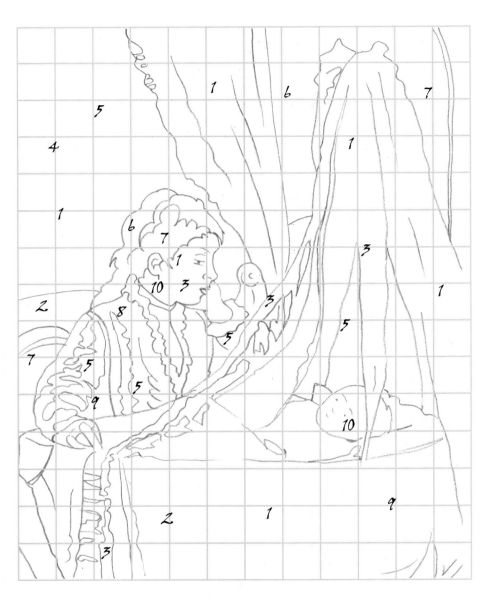

1 White
2 Cadmium yellow
3 Cadmium red
4 Ultramarine
5 Payne's grey
6 Burnt umber
7 Burnt sienna
8 Violet
9 Yellow ochre
10 Flesh tint

PALMER *THE MAGIC APPLE TREE* pages 82–85

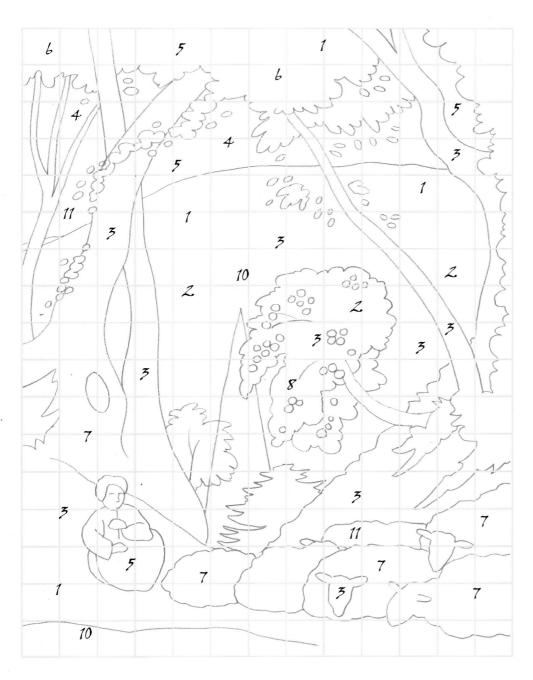

1 Chrome yellow
2 Vermilion
3 Burnt sienna
4 Ultramarine
5 Prussian blue
6 Viridian green
7 Sepia
8 Carmine
9 Yellow ochre
10 Crimson
11 White

PISSARRO *RED ROOFS* pages 86–89

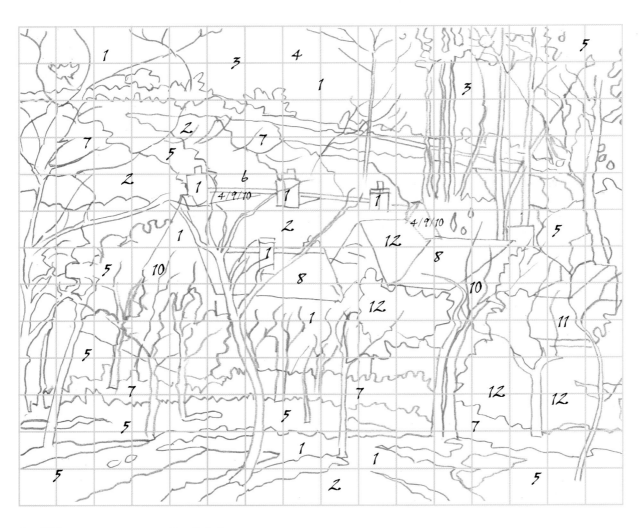

1 White

2 Cadmium yellow

3 Burnt sienna

4 Ultramarine

5 Violet

6 Sap green

7 Cadmium orange

8 Cadmium red

9 Prussian blue

10 Payne's grey

11 Flesh tint

12 Yellow ochre

REDON *FLEURS* pages 90–93

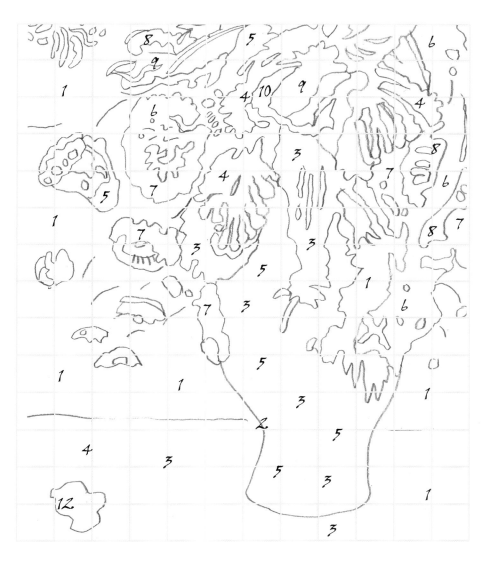

1 Yellow ochre

2 Raw sienna

3 Sap green

4 Cadmium yellow

5 Black

6 Cadmium orange

7 Cadmium red

8 Cerulean blue

9 Cobalt blue

10 Violet

11 Payne's grey

12 Pink

RENOIR *BOATING ON THE SEINE* pages 94–97

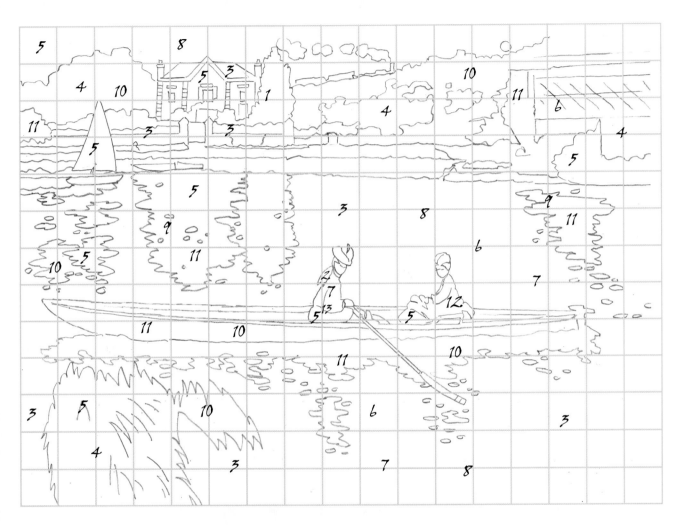

1	Yellow ochre	8	Ultramarine
2	Burnt sienna	9	Flesh tint
3	Cobalt blue	10	Cadmium yellow
4	Sap green	11	Raw sienna
5	White	12	Crimson
6	Violet	13	Lilac
7	Payne's grey		

RENOIR *THE SWING* pages 98–101

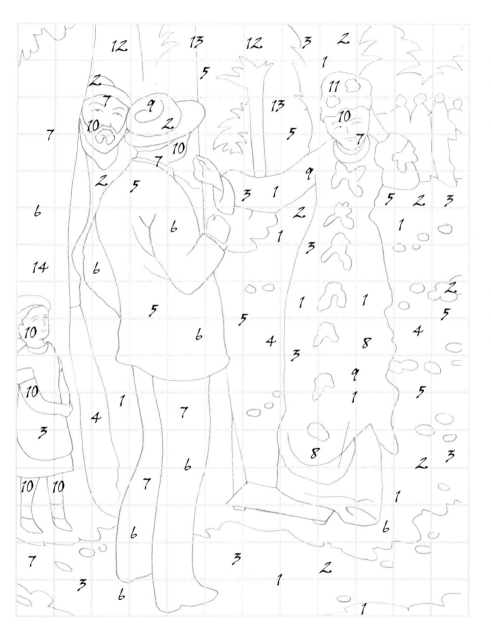

1 Payne's grey

2 Yellow ochre

3 White

4 Cerulean blue

5 Ultramarine

6 Violet

7 Cadmium red

8 Crimson

9 Cadmium yellow

10 Flesh tint

11 Burnt umber

12 Phthalo green

13 Emerald green

14 Burnt sienna

SCHIELE *WOMAN WITH BENT KNEE* pages 102–105

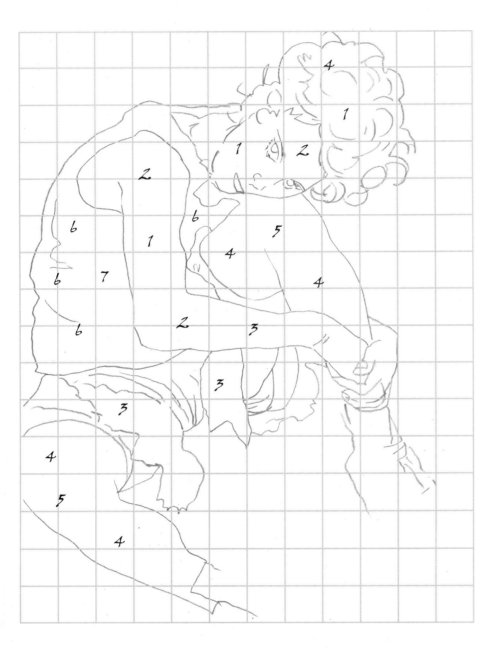

1 Cadmium red

2 Yellow ochre

3 White

4 Burnt sienna

5 Black

6 Emerald green

7 Ultramarine

Specified touches of the following

dry media are covered in the steps:

• Brown colouring
 pencil

• Black wax crayon

• 2B graphite pencil

SEURAT *THE CIRCUS* pages 106–109

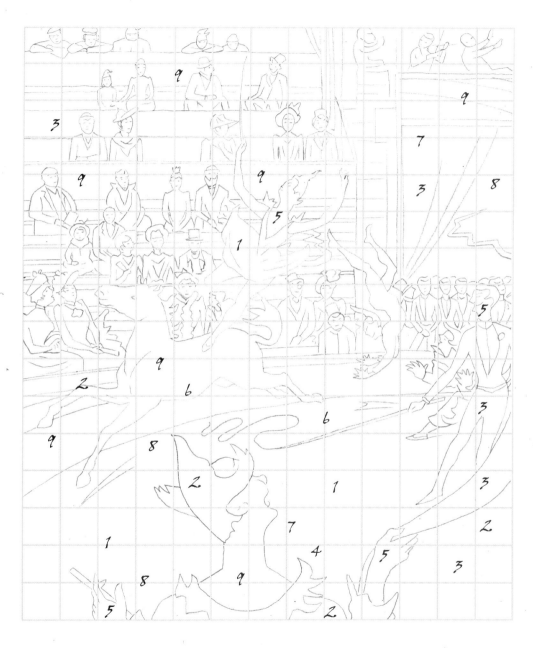

1 Cadmium yellow
2 Cadmium red
3 Yellow ochre
4 Burnt sienna
5 Flesh tint
6 Cobalt blue
7 Ultramarine
8 Violet
9 White

SISLEY *SNOW AT LOUVECIENNES* pages 110–113

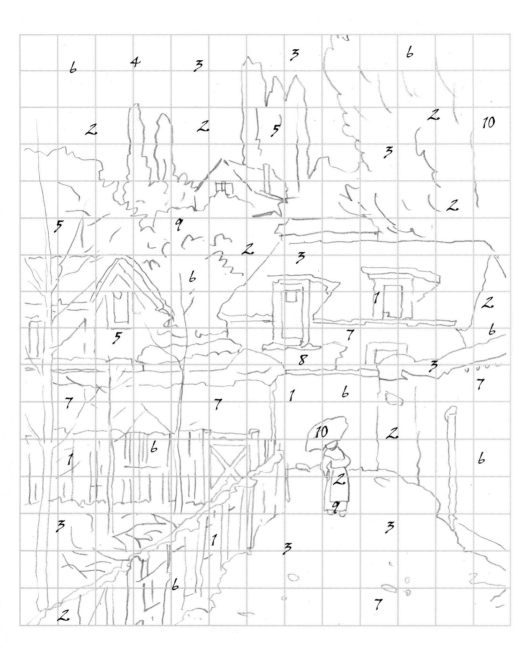

1 Burnt sienna

2 Payne's grey

3 White

4 Ultramarine

5 Violet

6 Yellow ochre

7 Flesh tint

8 Raw sienna

9 Prussian blue

10 Sap green

TOULOUSE-LAUTREC *CHA-U-KAO*
THE FEMALE CLOWN pages 114–117

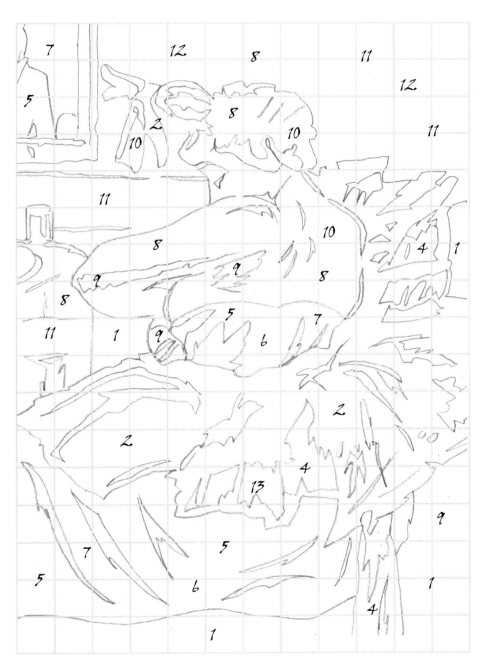

1 Burnt sienna

2 Cadmium yellow

3 Raw sienna

4 Bright green

5 Ultramarine

6 Cobalt blue

7 Payne's grey

8 White

9 Violet

10 Yellow ochre

11 Cerulean blue

12 Phthalo green

13 Burnt umber

14 Lilac

TURNER *THE FIGHTING TEMERAIRE* pages 118–121

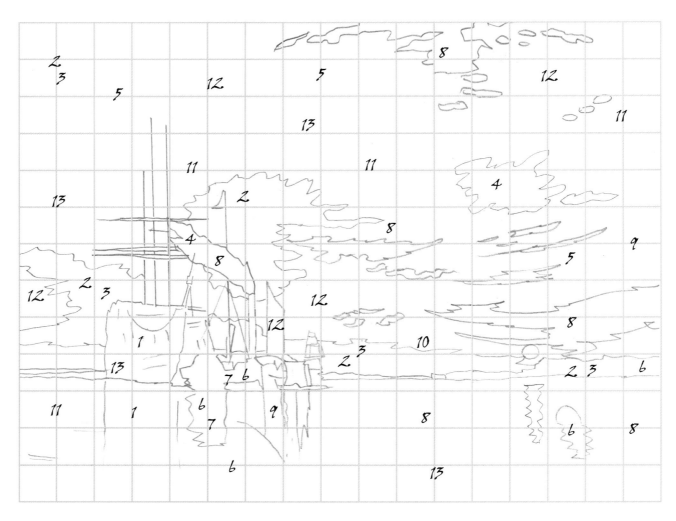

1	Burnt sienna	*8*	Cadmium red
2	Ultramarine	*9*	Cadmium orange
3	Cerulean blue	*10*	Cobalt blue
4	Cadmium yellow	*11*	Payne's grey
5	Lemon yellow	*12*	White
6	Burnt umber	*13*	Yellow ochre
7	Black		

VAN GOGH *WHEATFIELD WITH CYPRESSES* pages 122–125

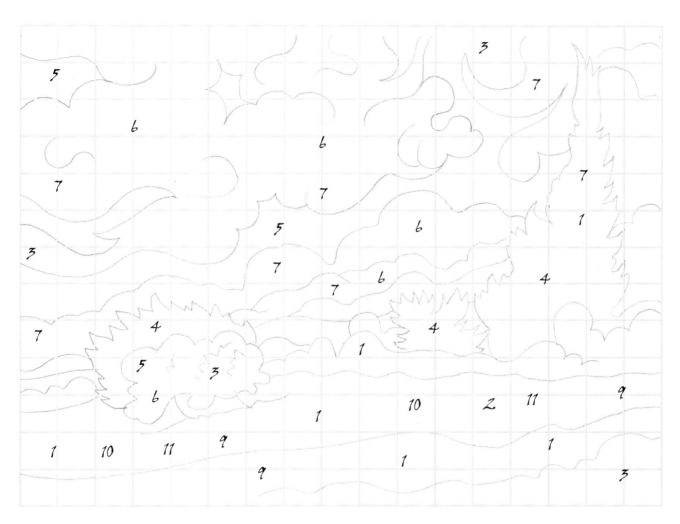

1 Yellow ochre

2 Cadmium yellow

3 Bright green

4 Phthalo green

5 Cerulean blue

6 White

7 Ultramarine

8 Crimson

9 Burnt sienna

10 Burnt umber

11 Lemon yellow

VAN GOGH *SUNFLOWERS* pages 126–129

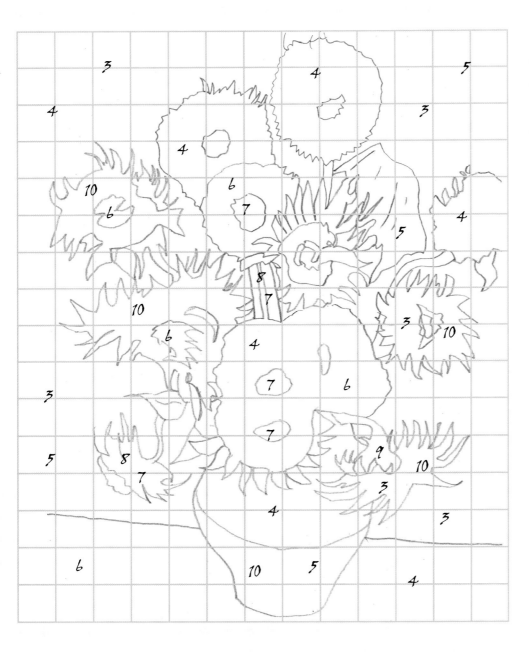

1 Burnt sienna
2 Raw umber
3 Cadmium yellow
4 Raw sienna
5 White
6 Burnt umber
7 Sap green
8 Bright green
9 Payne's grey
10 Yellow ochre

VAN GOGH *CHAIR AND PIPE* pages 130–133

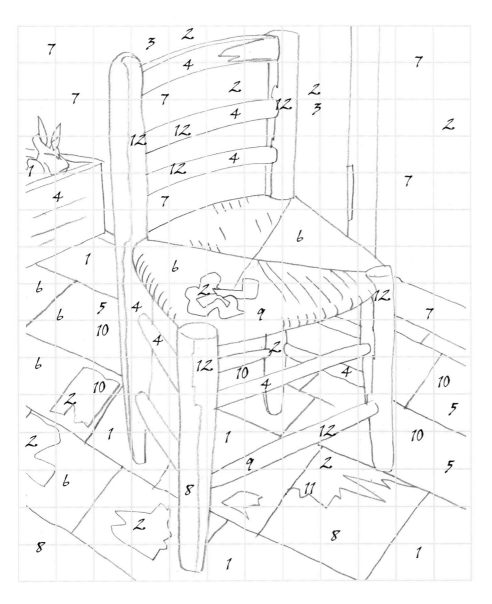

1 Burnt sienna
2 White
3 Cobalt blue
4 Cadmium yellow
5 Raw sienna
6 Burnt umber
7 Cerulean blue
8 Bright green
9 Yellow ochre
10 Cadmium red
11 Flesh tint
12 Lemon yellow

VERMEER *GIRL WITH A PEARL EARRING* pages 134—137

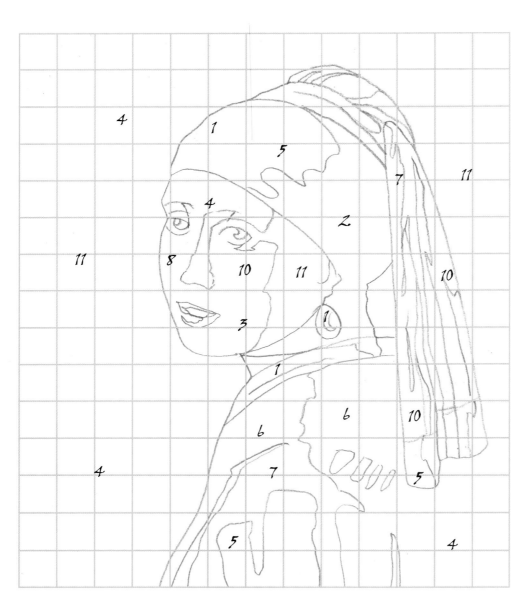

1 White
2 Payne's grey
3 Raw sienna
4 Burnt sienna
5 Prussian blue
6 Sap green
7 Yellow ochre
8 Flesh tint
9 Crimson
10 Cadmium yellow
11 Burnt umber
12 Cadmium red

WHISTLER *PORTRAIT OF THE ARTIST'S MOTHER* pages 138–141

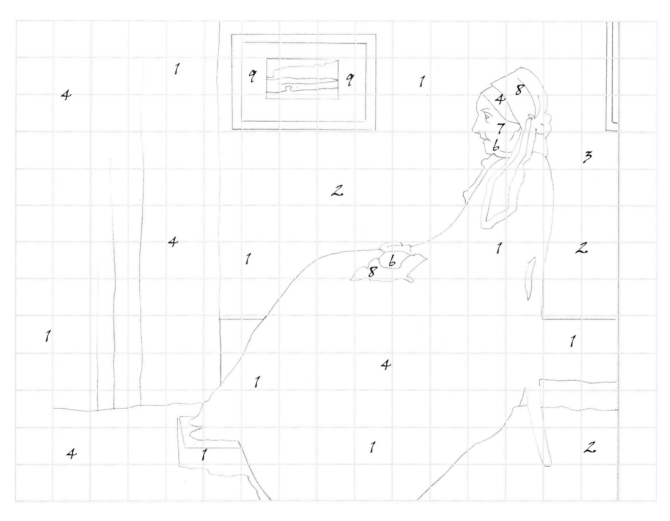

1	Payne's grey	6	Flesh tint
2	Sap green	7	Cadmium red
3	Raw sienna	8	White
4	Burnt umber	9	Yellow ochre
5	Raw umber		

GLOSSARY

Acrylic paint Paint in which the pigment is bound with a synthetic, acrylic binding medium. Can be diluted with water, but unlike watercolour, the paint film is insoluble once dry.

Aerial perspective The use of colour, tone and texture to create an illusion of space in a painting. As objects recede towards the horizon, they appear paler and bluer, and their edges become less defined.

Backruns Jagged-edged blotches that occasionally occur when new watercolour paint is added into a wash that has not fully dried. Backruns can look unsightly if the colour area is intended to be flat, but they can be an attractive feature of a painting.

Binder/binding medium A liquid medium that is combined with a pigment to form a paint, such as linseed oil for oil paint or gum arabic for watercolour.

Bleed The effect achieved when a wash of watercolour, or other thin medium, runs into an area of wet colour to create a softly blurred and blended mix of colour.

Blending Merging adjacent colours so that the transition between the colours is imperceptible.

Blocking-in The first stage of a painting in which the main forms of the composition are laid down as approximate areas of colour and tone.

Body colour Describes pure transparent watercolour that has been rendered opaque by adding white to the mix. Sometimes also used to describe gouache.

Broken colour (1) A pure colour (primary or secondary) to which a third colour has been added. The result is a muted, greyed or knocked-back colour. (2) Paint applied as small dabs or dashes or scumbles, so that when viewed from a distance, it creates an optical mix.

Brushwork The characteristic way each artist brushes paint onto a support, often regulated as a 'signature'; used to help attribute paintings to a particular artist.

Chiaroscuro The use of light and dark in a painting or drawing. A term applied especially to the work of painters, such as Rembrandt and Caravaggio, who used strong contrasts of light and dark.

Cold-pressed (CP) Watercolour paper with a medium-textured surface achieved by pressing the paper between cold rollers in the manufacturing process. Also called NOT paper.

Complementary colours Colours that are opposites on the colour wheel. The three primaries are complemented by a secondary: red by green, blue by orange, yellow by violet. A colour can be knocked back by adding a touch of its complementary pair.

Composition The organisation of tone, colour and form within a picture.

Conté crayon Square, pastel-like crayon.

Crosshatching Tone created by layers of parallel, crisscrossing lines.

Dilutant A liquid that is used to dilute paint, such as turpentine (for oil paint) or water (for watercolour or acrylic). It evaporates completely and does not become part of the final paint.

Dip pen Drawing and writing tool consisting of a handle, or holder, and a changeable nib.

Dry brush In this technique, a brush with very little paint on it is dragged across the support to create areas of broken colour or texture.

Figurative art Art that depicts recognisable subjects, such as the human figure or landscape, in a realistic way.

Fixative A transparent liquid applied to works executed in media such as pastel and charcoal, which do not have good adhering qualities. The fixative helps to attach the particles to the support and protects the fragile surface.

Gesturally Energetically, with less rigid control, emphasising the idea with emotion in the marks.

Glazing The application of a transparent film of colour over another colour.

Gouache An opaque form of watercolour sometimes described as a body colour.

Graphite A type of carbon used in the manufacture of a lead pencil.

Grid system A method by which proportions and perspective may be accurately rendered. A grid is drawn on the paper before the artist begins work. While working, the artist then mentally superimposes the same grid on the subject.

Ground A substance applied to any support to isolate it from the paint film and to provide a pleasant surface on which to paint.

Gum arabic A water-soluble gum derived from a species of acacia tree. It is used as a binder in watercolour and gouache paint. It can also be added to watercolour to enhance colour and texture.

Highlight Emphatic patches of light, usually on a smooth or reflective surface.

Horizon line An imaginary line that stretches across the subject at your eye level, where the vanishing point or points are located. The horizon line in perspective should not be confused with the line where the land meets the sky, which may be considerably higher or lower than your eye level.

Hot-pressed (HP) Watercolour paper that has a smooth surface created by pressing between hot rollers during the manufacturing process.

Hue The colour of a colour – its redness or blueness.

Impasto Paint applied thickly so that it retains the mark of the brush or knife.

India ink Used with a steel-nib dip pen, India ink dries with a slight gloss. The ink may be diluted with water to create softer colour and greater fluidity.

Intensity The purity and brightness of a colour. Also called saturation or chroma.

Lifting out A technique used in watercolour and gouache work involving removing wet or dry paint from the paper with a brush, sponge or paper towel to soften the edges or make highlights. Wet paint is often lifted out to create cloud effects.

Medium (1) The material used for a painting or drawing, such as watercolour, acrylic or pencil. (2) A substance added to paint to modify the way it behaves.

Mixed media A work executed in more than one medium.

Monochrome A drawing or painting executed in a single colour.

Neutral True neutrals are greys that are mixed from the three primary colours: red, yellow and blue. Generally, the word refers to a mixture of colours that approaches grey.

NOT Another term for cold-pressed watercolour paper applied because it has 'not' been hot-pressed.

Opacity The covering or hiding ability of a pigment to obliterate an underlying colour.

Optical colour mixing Creating new colours by placing separate patches of colour side by side on the canvas so that they blend in the eye of the observer.

Outline drawing Not to be confused with line drawing, an outline drawing offers a basic rendition of the objects in the picture without giving it three-dimensional form.

Overlaying The style of laying or putting one colour or tone on top of another.

Painting knife A knife with a thin, flexible steel blade and a cranked handle. The knife is used to apply paint to the support.

Palette (1) A tray or a dish in which paint is mixed. (2) A selection of colours.

Pastel Sticks of colour, either cylindrical or square-shaped, made by mixing pure pigment with gum tragacanth. Available in soft and hard versions.

Permanence Refers to a pigment's resistance to fading on exposure to sunlight.

Picture plane The imaginary vertical plane that separates the viewer from the world of the picture. The picture plane is an important concept in linear perspective.

Pigment The colouring substance in paint. May be derived from natural materials, such as earths and minerals, or from synthetic sources.

Priming Applying a ground to a support.

Reflected light Sometimes light from the main source carries beyond the object, glances off other things, and bounces back, leaving a lighter strip against the edge on the darker side of the object. This is known as reflected light.

Rendering Drawing or reproducing a subject.

Resist A technique that involves two materials that do not mix well together. For example, if wax crayon or oil pastel is applied under watercolour, the crayon or pastel will 'resist' or repel the watercolour to create an interesting effect.

Rough A watercolour paper with a noticeably textured surface.

Scale The accurate representation of all elements within a drawing in exact proportion to one another.

Scumbling A painting technique in which a thin, broken layer of opaque paint is applied over an existing colour. The underlying paint shows through the top layer, creating an optical colour-mixing effect.

Shading The method by which objects are made to appear three-dimensional. The simplest practice is to vary the amount of pressure exerted on the pencil or charcoal to vary the density of the ensuing marks.

Spattering A watercolour technique in which texture is created by flicking colour from a brush onto the support.

Stippling An effect created by holding the brush upright and dabbing the tip onto the support to create dots of colour. Stippling can also be created with a special stippling brush that has short, stiff bristles that have been cut to create a flat end.

Support Any surface used for painting or drawing.

Tint (1) Term for a colour lightened with white. (2) The dominant colour in a mix of colours.

Tone The lightness or darkness of a colour.

Underpainting The preliminary blocking-in of the main forms, colours and tonal masses.

Underdrawing A preliminary drawing for a painting, executed on the support. Can be made in a drawing medium or in paint.

Value Tonal value, sometimes referred to merely as 'value'.

Vanishing point In linear perspective, this is the point at which parallel lines appear to meet at the horizon.

Viewpoint The position or angle chosen by the artist from which to paint a scene or object. By changing the position, a number of alternative compositions may be attempted.

Volume The space that a two-dimensional object or figure fills in a drawing or painting.

Wash In watercolour painting, diluted colour applied thinly to the support to create a transparent film.

Wet-in-wet Laying a new colour before the previous one has dried. In watercolour this creates a variety of effects, from softly blended colours to colour 'bleeds' and backruns. In oils the effects are less dramatic, but each new colour is slightly modified by those below and adjacent, so that forms and colours merge into one another without hard boundaries.

Wet-on-dry In watercolour, applying paint to a dry support or over paint that has been left to dry. This technique creates crisp edges.

INDEX

ACKNOWLEDGEMENTS

Picture Credits
Bridgeman Art Library, London: 30 (Courtauld Institute, London), 62 (Saarland Museum, Saarbrücken), 78 (Musée d'Orsay, Paris), 82 (Fitzwilliam Museum, Cambridge), 86 (Giraudon/Musée d'Orsay, Paris).
CORBIS: 54 (Art Institute of Chicago), 58 (Austrian Archives/Österreiche Galerie, Vienna), 70 (Christie's Images), 98 and 106 (Edimedia/Musée d'Orsay, Paris), 114 (Archivo Iconographico S.A.).
CORBIS/Francis G.Meyer: 22 (Uffizi, Florence) 38 (Musée d'Orsay, Paris), 46 (Metropolitan Museum of Art, New York), 134 (Mauritshuis, Hague), 138 (Musée d'Orsay, Paris).
CORBIS/© National Gallery Collection: by kind permission of the Trustees of the National Gallery, London: 2, 94, 118, 122, 126, 130.
Denver Art Museum, Colorado: 34.
Graphische Sammlung, Albertina, Vienna: 42.
Kunstmuseum St. Gallen, Switzerland: 90.
Narodni Galerie, Prague: 102.
Phillips Collection, Washington: 110.
Toledo Museum of Art, Ohio: 50.

Author Acknowledgements
Curtis Tappenden wishes to thank David Clare for his early encouragements and Ivan for his master forgery with brush and nib. Thanks, too, go to Peter, Sophie, Steve, Caroline, Tonwen and all at Ivy Press for their support and hard work. Final thanks to Susanne, Tilly and Noah for their constant love and support.